IMAGES
of America

MEDINA

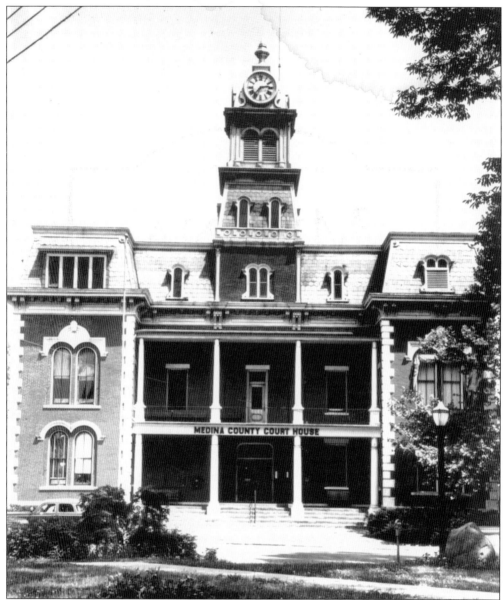

The Medina County Court House is a local landmark that has dominated the square since 1841. It withstood two destructive fires in the 19th century and an effort in the mid-1960s to tear it down and replace it with something modern. Because of later alterations, it is now French Second Empire in style. Barely distinguishable through the porch columns is the original Greek Revival building, which was enveloped by two large wings and topped with a bell tower in 1873. The courthouse is now on the National Register of Historic Places. (Courtesy of Community Design Committee.)

On the cover: Although the gazebo in the center of Public Square Park looks as thoroughly Victorian as all the buildings lining the square, it is actually a 1975 reproduction of a gazebo in another Ohio town. Once in place, however, it quickly became a beloved landmark and a visual metaphor for the city. (Courtesy of Community Design Committee.)

IMAGES
of America

MEDINA

Gloria Brown

ARCADIA
PUBLISHING

Published by Arcadia Publishing
Charleston SC, Chicago IL, Portsmouth NH, San Francisco CA

Printed in the United States of America

Library of Congress Catalog Card Number: 2006934715

For all general information contact Arcadia Publishing at:
Telephone 843-853-2070
Fax 843-853-0044
E-mail sales@arcadiapublishing.com
For customer service and orders:
Toll-Free 1-888-313-2665

Visit us on the Internet at www.arcadiapublishing.com

For David, Jessica, and Jeremy.

CONTENTS

ACKNOWLEDGMENTS

The author would like to express her gratitude to the following organizations and individuals for their help and the loan of their valuable photographs: the Medina County Historical Society (MCHS) and Brian Feron and curator Tom Hilberg (with special thanks to Hilberg for all his help and endless patience); the Community Design Committee (CDC), especially members Cynthia Szunyog, Drew Phillips, Roger Smalley, Janet Lipstreu, and Joann King; to Medina Cable Access and its employees Jarrod Fry and Miles Reed (with special thanks to Reed for his technical and artistic assistance); Medina County District Library; Friends of the Cemetery; First Merit Bank and its vice president, Jeffery Palker; and the A. I. Root Company with special thanks to John Root and Kim Flottum. I would also like to express gratitude to the following individuals: Frederick Graff; David Kellogg; Elaine Lamb; Tom Lehrer; Ronald Linek; Chuck and Nancy Masi; Muffy McDowell; Pam Miller; Janet Moxley; Dr. Will Nichols; Nancy Recchie; Mickey Sailer; Don Simmons; Betsy Whitmore; Betty, Elmer, and Kim Zarney; my editor, Melissa Basilone; and of course, to my husband, David Brown.

INTRODUCTION

Medina was discovered by Hollywood in the 1940s and called "Hometown USA." After the restoration of its Victorian square in the 1970s, it was rediscovered by greeting card companies, advertising agencies looking for locations for commercials, and thousands of new residents—all searching for that perfect piece of vanishing America. However, Medina's story is more than just a beautiful public square; it has a history that goes back almost 200 years.

The City of Medina was founded in 1818 by Elijah Boardman, a wealthy businessman and land speculator from Connecticut. Boardman was a member of the Connecticut Land Company, a group of investors who purchased the Western Reserve—some three million acres along the southern shore of Lake Erie in what is today northeastern Ohio—from the state of Connecticut in 1796. This had been part of an old land grant given to the Colony of Connecticut by King Charles II of England in 1662.

In the spring of 1807, the Connecticut Land Company held a drawing for its shareholders. Boardman extracted Township No. Three in the 14th Range, which became Medina Township. He had it surveyed and divided it into lots, but the area was not safe for settlement until after the War of 1812, when the British were finally defeated and the threat of Native American uprisings was removed.

In 1816, Boardman hired Rufus Ferris Sr. of Connecticut to sell lots to the settlers who began arriving, mostly from New England and New York State. These settlers, traveling in wagons drawn by oxen or on foot, encountered a wilderness filled with forests so dense that daylight barely penetrated the canopies of the trees. It was a harsh environment, yet full of possibilities. For those willing to undergo hardship and danger, it took only one generation to make this wilderness habitable and productive.

When Medina was incorporated in 1835, it had already grown into a thriving village. The humble log cabins with dirt floors of the first arrivals had been replaced by frame structures in the Federal or Greek Revival style, which were reminiscent of houses in the East.

Then on the evening of April 11, 1848, disaster struck. A fire ignited by a carelessly tossed candle destroyed a large part of the business district on Public Square. Using their own resources, the citizens quickly rebuilt them.

One merchant, Harrison Gray Blake, named his newly rebuilt structure the Phoenix Store, a reference to the sacred bird of mythology that was reborn from its own ashes.

By the late 1850s, Medina was fully settled. Even though the rural village was isolated and only connected to the rest of the state by a very slow stagecoach that carried mail and passengers, the citizens were passionately interested in the major issues of the day. Abolition of slavery was one

such issue, and one of Medina's most prominent citizens, H. G. Blake, maintained a station of the Underground Railroad in his home, one of several such stations in the area.

Medina supported Abraham Lincoln in the election of 1860. When war broke out, some 200 young men enlisted—a number of them were assigned to the 42nd Regiment, referred to as "Garfield's Own" because Ohioan James Garfield, the future president, raised and commanded the regiment.

On April 14, 1870, a second and even more devastating fire broke out on the square, leveling 45 buildings and destroying most of the town records in the courthouse. Undaunted, Blake rallied the citizens and was one of the first to rebuild again. Once again, he named his building the Phoenix. Within a decade, the entire square was reborn in a uniform Victorian style.

During the last decades of the 19th century, Medina entered the Industrial Age. In 1871, the railroad connected the village with the rest of the country, and in 1897, the Interurban Electric, part of the Cleveland, Southwestern and Columbus Railway, provided inexpensive transportation to nearby cities and towns. The A. I. Root Company, a manufacturer of beekeeping supplies, and the Medina Foundry (which later became the Hollow Ware Factory, then the Henry Furnace Company) became important industries. The beloved Medina tradition of the Decoration Day (now Memorial Day) parade, with its march around the square, began as a way to honor Civil War veterans.

The post–World War II decade represented a historic dividing line between the old and new Medina, between the slow-paced rural village it was, and the booming bedroom community it would soon become. The growth was so relentless that the village became a city in 1954. Pastures and cornfields on the outskirts of town rapidly turned into housing developments and industrial parks.

By the 1960s, Public Square was threatened with destruction once again. This time it was not by fire. Once the elegant centerpiece of the town, the Victorian square had become shabby and bedraggled and covered over with garish neon signs and inept efforts at modernization. The businesses were rapidly losing customers to shopping centers in Medina County and elsewhere. There was talk of tearing down the courthouse and turning part of the square into a parking lot.

At this point, a group of determined citizens banded together and performed a miracle. Calling themselves the Community Design Committee (CDC), they pored over vintage photographs and history books, consulted with preservation groups across the country and within six years, had accomplished a privately financed, award-winning restoration of the square. This revitalized the businesses by creating specialty shops on the square, which attracted tourists and locals alike. The phoenix had risen from its ashes one more time.

One

IN THE BEGINNING

The New England Yankees who settled Medina Township had great faith in three institutions, the church, democracy, and education. In keeping with these values, a group of settlers assembled at daybreak on April 10, 1817. Trees were felled and hewed, shingles were cut, and by 4:00 p.m. that afternoon, a small log cabin had been constructed. An Episcopal minister conducted a service that same day, followed by the Congregational minister. This little log cabin, pictured in *The First One Hundred and Fifty Years of St. Paul's Episcopal Church, Medina, Ohio 1817–1967* by James Baldwin, also served as a school and meeting hall.

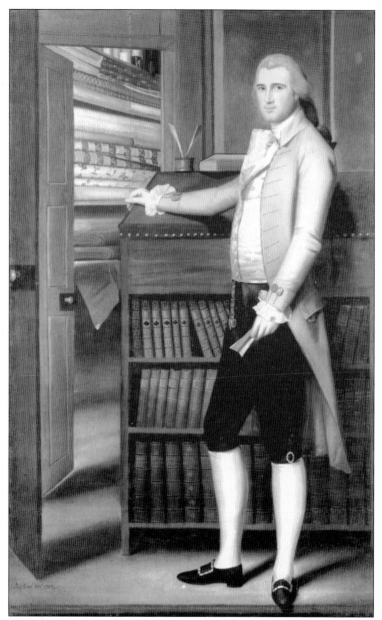

Elijah Boardman, the founder of Medina, was born in 1760 in New Milford, Connecticut, and served in the Revolutionary War. In 1781, he and his brother built a dry goods store in New Milford. Boardman became wealthy from this business, as well as from other investments and business ventures. Eventually he was considered one of the wealthiest men in New England. This 1789 painting by American artist Ralph Earle depicts Boardman in his prime, a handsome, richly dressed gentleman standing before a desk filled with books (to indicate that he is well read). He is turned toward an open door leading to a shop that is well stocked with goods (to show the source of his wealth). In later life, Boardman entered politics and served in the Connecticut state legislature before being elected to the United States Senate in 1821. He died in 1823 while visiting his son in Boardman, Ohio, the other community he founded. (Courtesy of the Metropolitan Museum of Art.)

In April of 1817, Elijah Boardman assigned 227 acres in Medina Township for the purpose of creating a county seat. The wording of the original deed reads, "In consideration of one dollar and the fixing of the seat of justice for Medina County in Medina Township . . . we do give and bequeath to Lathrop Seymour, 'Director of the Town of Medina' in trust for the use and benefit of the people of Medina County, the aforesaid land." Four lots facing Public Square were reserved for public buildings. Also reserved was the land which now makes up Public Square Park and the Old Town Graveyard. The town was called Mecca, until it was discovered that another town in nearby Trumbull County was already called by that name. The name Medina was then chosen. (Courtesy of CDC.)

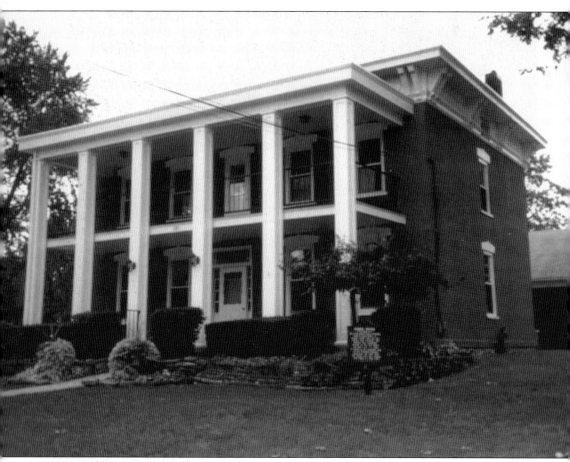

The first settler in the village of Medina was Rufus Ferris Sr., hired by Elijah Boardman to act as his land agent. Ferris built a log cabin one-half mile from the square. A short time later, he erected a large frame barn in which the first county court session was held in 1818. Ferris became a man of some prominence in the village. He was appointed the first county treasurer and also served as postmaster of the newly created Medina Post Office, which was located in his home. In 1825, Ferris built this imposing brick home, which he operated as an inn for the coach that ran regularly from Cleveland to Wooster and stopped in Medina. His home boasted 10 rooms and eight fireplaces. After he died in 1834, his wife continued to operate the inn until 1845. Eventually this structure became a private home, at which time the square roof and columns were added. It is now a law office. (Courtesy of David Brown.)

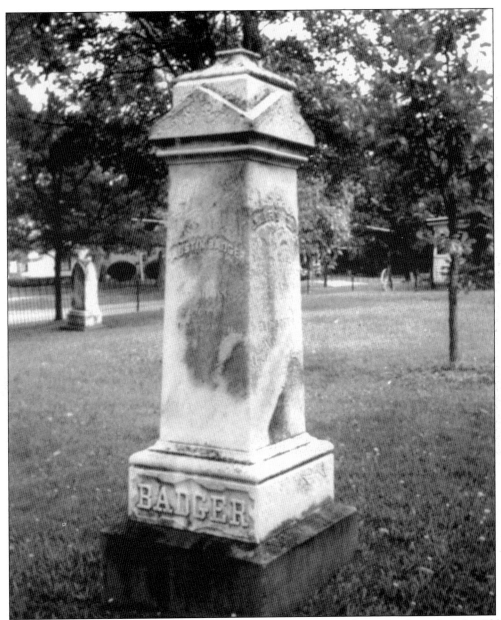

Capt. Austin Badger was the first resident on Medina's square and now lies buried in the Old Town Graveyard. Born in Green, Chenango County, New York, in 1793, he volunteered for the militia when the War of 1812 began and was present when the British burned Buffalo. In 1818, having arrived in Ohio, he walked from Cleveland to Medina. Hired as Medina's first resident surveyor, he built the first building on the square, a two-story log cabin on the northwest corner. The first story served as a community house, or tavern, and the second story was a court room. He also surveyed and laid out the park on Public Square and the surrounding streets. Badger presided over Medina's first Fourth of July celebration in 1820. He tied a bandana kerchief to a pole—the closest thing to an American flag then available—which he stuck into a hollow beech stump, and the settlers then named the main streets of the village: Liberty, Washington, Court, and Broad Way Streets. He died at the age of 90. (Courtesy of David Brown.)

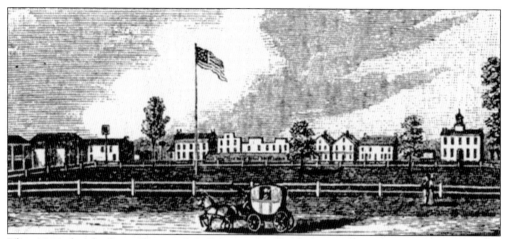

This 1846 sketch, from *Historical Collections of Ohio* by Henry Howe, is the only existing image of Public Square before the 1848 fire. It shows a New England–style village with white clapboard buildings clustered around a village green. The Village of Medina was incorporated in 1835 and boasted a population of 118 by 1846. There were two churches, Episcopal and Congregational, a stagecoach inn, a raucous tavern (Mark's Hotel, "where all the blights in town got started"), a dry goods stores, a doctor (who doubled as the post master), a lawyer, and two courthouses. The first courthouse (seen directly behind the flagpole) was completed about 1826, but proved to be inadequate.

This is the 1826 courthouse today, significantly modified. A close examination reveals the outlines of the original, Federal-style building. This structure proved to be surprisingly resilient. It survived the fires of 1848 and 1870 and remains intact and in use today. Over the years, it has served as a residence and has, for many years, been the location of Whitey's Army-Navy Store, a Medina institution. (Courtesy of David Brown.)

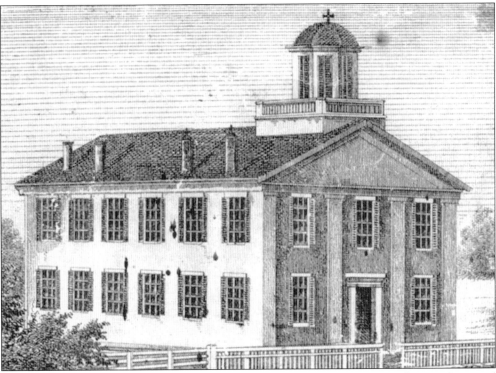

The new courthouse was built in 1841, a two-story Greek Revival structure with a cupola topped by a gilded ball 16 inches in diameter (now stored at the Medina County Historical Society). It survived the fires of 1848 and 1870, although most of the village records stored there were destroyed. (Courtesy of MCHS.)

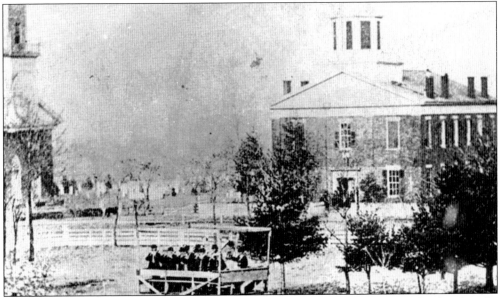

This 1848 photograph shows the courthouse as well as a portion of the Old Brick Church—the 1832 Congregational church, which was replaced in 1882. It also shows an early band concert in the park. (Courtesy of MCHS.)

The ground for the old cemetery was donated by 1 when he first had the village platted in 1818. However, the land was not formally deeded to the village until 1836, some years after Boardman's death. His son, Henry Boardman, carried out his father's wishes by giving the village the "east half of lots 97 and 98 as a burying ground for the use of inhabitants of Medina." Many stones are marked with war veteran stars, some dating to the Revolutionary War. (Courtesy of David Brown.)

In the early 19th century, East Liberty Street, which runs alongside the cemetery, was called the Graveyard Road. H. Durham, who lived in Medina as a child in the 1840s recalled, "It was on this road that the bodies of the dead were taken to their final resting place upon a bier with four legs carried by four men and covered with a black pall, while a bell solemnly tolled as long as the procession was on its way." Several of the tall, flat tombstones were carved from Weymouth sandstone by Israel Perkins. (Courtesy of CDC.)

This classic Greek Revival home was built in 1829 by Noah Bronson for William H. Canfield, a successful attorney, county auditor, and judge. The house, which originally stood on the southeast corner of the square, survived the fires of 1848 and 1870, although Canfield lost his barn in the 1848 conflagration. The house was moved to its present location on South Broadway Street in 1910. (Courtesy of David Brown.)

Constructed about 1830, this structure is the last wood frame building to survive intact from the early days of the village. In the 1850s, it served as the law offices of Canfield and Kimball and in later years, housed a mercantile shop. About 1910, it was purchased by Dr. William Abner Nichols, and two generations of the Nichols family practiced dentistry there until 1963. (Courtesy of David Brown.)

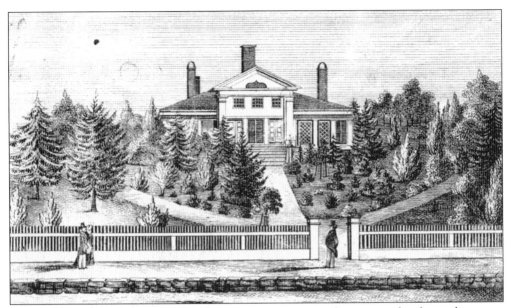

Although the name Bronson is largely forgotten now except for a street that bears the name, Hiram Bronson was an important figure in the early days of Medina. In 1840, he built this home, the Rose Cottage, on the northwest corner of West Liberty and North Elmwood Streets. The cottage was moved to another location on North Elmwood Street when Bronson built an even more imposing home in 1870. A painting of the Rose Cottage, signed by Sherman Bronson, now belongs to the MCHS. (Courtesy of MCHS.)

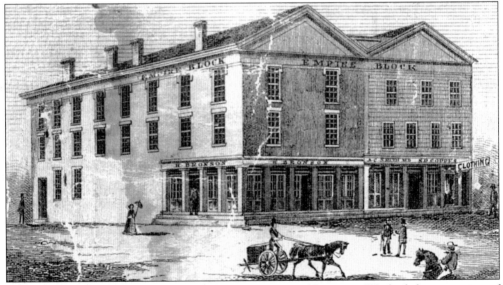

H. Durham, a chronicler of Medina in the 1840s, wrote of Bronson, "He had the reputation of having the best dress goods in town." Bronson was extremely successful in business and at one time, in addition to his store, owned most of the northwest part of the village. He was elected sheriff of Medina County while in his 20s and served in the Ohio legislature from 1865 to 1869. Bronson donated a spectacular stained-glass window to St. Paul's Episcopal Church, where the family worshipped. He died in 1892 at the age of 90, the last of his family to live in Medina. (Courtesy of MCHS.)

18

Two

From 1848
to the Civil War

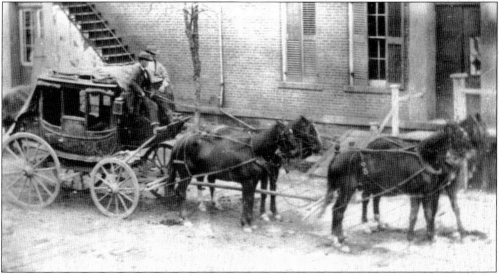

This photograph of the Cleveland–Columbus stagecoach was taken in 1862, on South Court Street next to Harrison Gray Blake's Phoenix building. Hiram V. Hall was the driver, and the team was owned by Dan Ainsworth. The plank road visible here was called the Wooster Pike. Toll gates were stationed at regular intervals on this road, and the revenues were used for upkeep. The stagecoach, which regularly arrived with passengers and mail, was the village's only contact with the outside world, since the nearest telegraph station was in Grafton, some 30 miles away. (Courtesy of MCHS.)

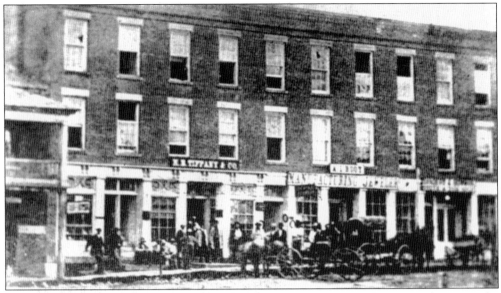

Late in the evening of April 11, 1848, a fire broke out and spread across the square, devouring the wooden buildings. Medina had organized a hook and ladder team, but unfortunately the men and equipment were scattered about the village. At dawn, the losses added up to six businesses, four dwellings, and two barns. Most of the buildings were uninsured. Nevertheless, the citizens rebuilt their businesses, some of them in a more substantial brick Federal style. Shown here is the west side of the square in 1868. (Courtesy of the MCHS.)

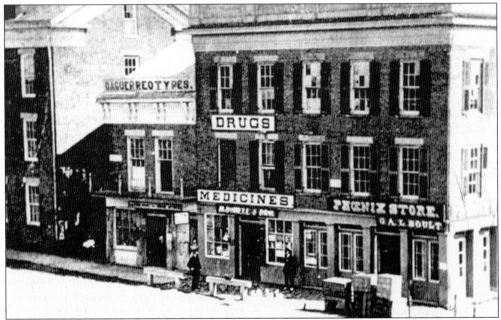

This is a photograph of the south side of the square during that same era. The Phoenix store belonged to H. G. Blake. At the age of 17, Blake, penniless and shabbily dressed, strolled into the village to answer an advertisement for a clerical position in a dry goods store. A few years later, he owned the store. When it burned down, he built this three-story brick structure in its place and named it after the mythological bird that rises from its own ashes. (Courtesy of the MCHS.)

Blake arrived in Medina County in 1831 as a 12-year-old orphan. His mother had perished in a Vermont blizzard and his father, crippled by frostbite and unable to work, gave him away to a family friend. Blake worked for several years clearing trees with his foster father and attended school sporadically. By the time this photograph was taken in the 1863, he had become a prosperous merchant, an attorney, an Ohio state senator, and a U.S. congressman. He had also started a small bank, the Phoenix Bank, now called First Merit Bank. (Courtesy of Drew Phillips.)

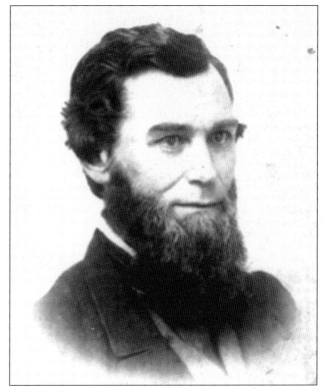

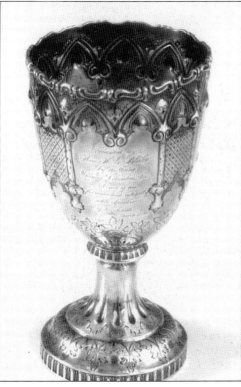

This silver cup was presented to Blake in 1850 by the Young Whigs of Ohio to commemorate his role in the repeal of Ohio's Black Laws, statutes that discriminated against free blacks living in the state. This was a difficult battle that involved a foiled kidnapping plot against Blake in the Ohio Statehouse. After being forewarned, Blake attended the legislature with loaded pistols at his sides. Afterward, Blake left the Whigs and helped create the new Republican party, which opposed slavery. (Courtesy of Ron Linek.)

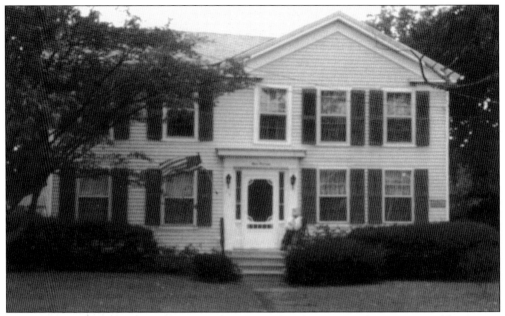

H. G. Blake, an ardent abolitionist, purchased this handsome 1840 house near Public Square and maintained a station on the Underground Railroad there. His daughter Elizabeth Blake McDowell recalled that as a child she saw slaves in the house. She told the story of how her father woke her one evening and said, "Come, I will show you something that will make you hate slavery forever." In the attic, she was shown a slave with a back that was scarred and disfigured from beatings by his master. (Courtesy of David Brown.)

This is another station on the Underground Railroad. This 1841 home is located on Weymouth Road, well outside Medina village during the Civil War era. It was built by Thomas Miller, an immigrant from England. The house is frequently toured by school children, who are intrigued by the panel behind the bookcase that reveals a hidden room and the trap door in front of the fireplace that leads to another room. (Courtesy of David Brown.)

John Renz, shown here in 1860, came to Medina at the age of 14 as an apprentice to John Rettig, a harness maker. He worked for Rettig until 1867 and afterwards entered into a partnership with Ephraim Brenner. In 1893, Renz bought out Brenner's share and established a shop on South Court Street with two of his sons. They handled not only harnesses, but also trunks, saddles, and other leather goods. The family continued to operate this store until the automobile forced them out of business. (Courtesy of MCHS.)

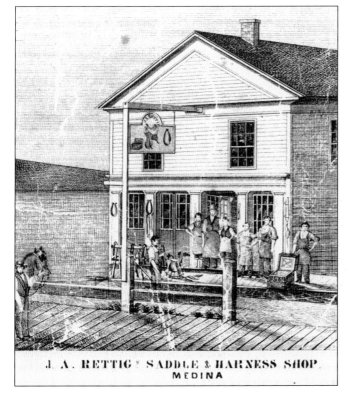

J. A. RETTIG SADDLE & HARNESS SHOP.
MEDINA

This 1857 sketch shows Rettig's saddle and harness shop where Renz apprenticed. Rettig was a close friend of H. G. Blake and occasionally helped Blake transport runaway staves to the next Underground Railroad station in Oberlin. (Courtesy of MCHS.)

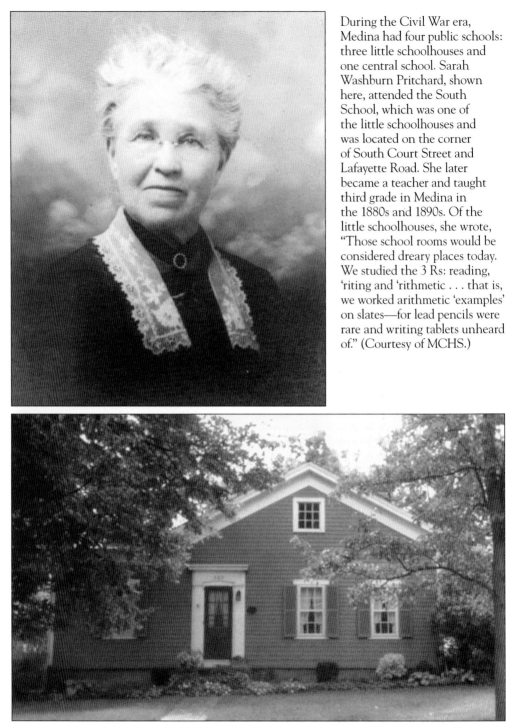

During the Civil War era, Medina had four public schools: three little schoolhouses and one central school. Sarah Washburn Pritchard, shown here, attended the South School, which was one of the little schoolhouses and was located on the corner of South Court Street and Lafayette Road. She later became a teacher and taught third grade in Medina in the 1880s and 1890s. Of the little schoolhouses, she wrote, "Those school rooms would be considered dreary places today. We studied the 3 Rs: reading, 'riting and 'rithmetic . . . that is, we worked arithmetic 'examples' on slates—for lead pencils were rare and writing tablets unheard of." (Courtesy of MCHS.)

Only one of the three little schoolhouses remains—the East School on the corner of East Liberty and North Harmony Streets. It was enlarged and is now a private home. The other little schoolhouses, the South School and the North School, were also turned into residences, but were torn down long ago. (Courtesy of David Brown.)

The village also offered private schooling. There were several "select" or private schools, usually held in private homes or church halls, and they charged tuition. One such private school was the Medina Select School, operated by William and Sarah Clark. Its precise location is unknown. It is only known that the school was "pleasantly located in a retired situation in Medina Village," and that it consisted of two stories. The enrollment was fairly large. During the 1850–1851 school year, 72 males and 68 females were registered, and of those, 30 were in a "normal" or teacher training course. Most students were from Medina village; others came from nearby communities and boarded with local families. The curriculum was quite extensive: intellectual philosophy, astronomy, Greek, Latin, and French grammar, music, and painting. Tuition ranged from $2.00 to $5.00 for a 16 week term. The faculty, on the other hand, was very small. It consisted of William and Sarah Clark and one "assistant pupil," Mary Griswold. (Courtesy of MCHS.)

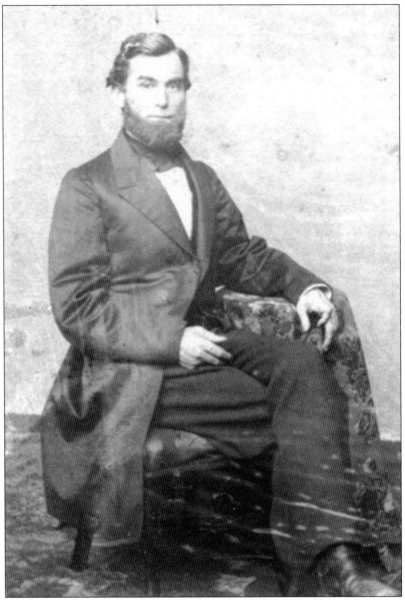

H. G. Blake served two terms in the U.S. Congress, from 1959 to 1963. During his years in the nation's capital, he wrote numerous letters to his wife about the progress of the Civil War and about some of the leading figures in Washington. On February 27, 1862, he writes, "There is a fight going on here across the river, I can hear the roar of the cannon but don't know what the result will be. I trust, however, that God will give us the victory." In another letter, on July 10, 1862, he describes the conflict between Pres. Abraham Lincoln and Gen. George B. McClellan. "I think the same of McClellan that I have for a long time and rejoice that the result is no worse. I think we shall have another fight in a few days and that we shall take Richmond in a short time. Mr. Lincoln has gone to Gen. McClellan's headquarters and is now there, and as I regard him as a great deal better General than McClellan, I think the fur will fly in that direction soon." When his second term was over, Blake was made colonel in the 166th Regiment of the Union Army, which served in the defense of Washington. (Courtesy of Drew Phillips.)

Three

THE PHOENIX RISES

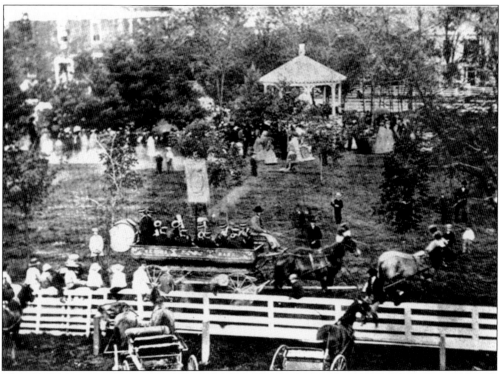

This 1866 photograph shows Public Square Park on a festive day. The park is thronged with carriages and fashionably dressed women. A band of musicians rides around the periphery of the park in a wagon pulled by gaily decorated horses. The trees are more profuse than they were a decade earlier. The war is over, many (but not all) of the young men are back, and a feeling of optimism prevails. (Courtesy of MCHS.)

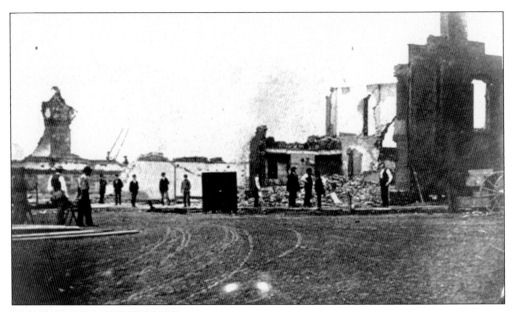

On the night of April 14, 1870, fire broke out again on Medina's Public Square. After the fire burned itself out the next morning, 45 buildings including stables and barns, were totally destroyed. Practically the entire business district around the square was destroyed. In the photograph taken the day after the fire (above), the charred remains of H. G. Blake's Phoenix building and his large safe are all that remain of his Phoenix Bank. Blake convened a meeting of townspeople on the steps of the courthouse the following day and urged them to rebuild. By July of that year, the framework for a substantial new business district was already in evidence. (Courtesy of MCHS.)

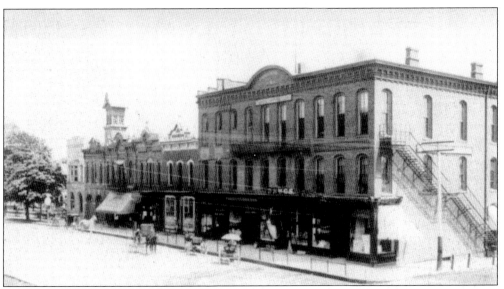

One of the first buildings to be rebuilt was Blake's Phoenix Block (buildings were called blocks because there were usually several businesses located within them). Built in the Eastlake Victorian style, it was one of the grandest buildings on the square. In addition to the bank and the businesses on the first and second floors, it featured a ballroom and a theater on the third floor, where most of Medina's important social events were held. (Courtesy of MCHS.)

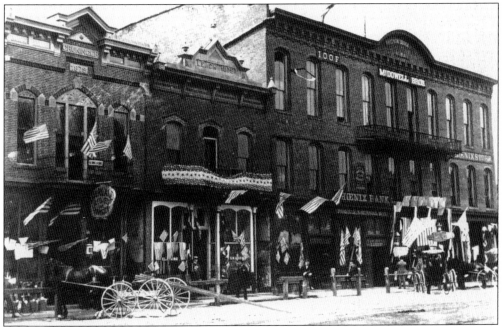

Within a decade, the square was filled with handsome Victorian buildings, some featuring ornate brickwork and ornamental cornices, with no two structures exactly alike. The business district bustled with activity. In this photograph, the square is festooned with flags, possibly for an election day. The 38-star flag indicates a date in the 1880s. The Gruninger Block was occupied by Munson's Hardware Store and the Leach Block was the site of a "clothing and gents' furnishing store" run by O. N. Leach. (Courtesy of MCHS.)

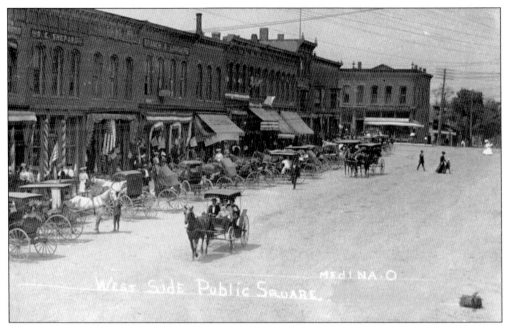

The west side of the square was also rebuilt in the Victorian style. Seen here is the Branch-Longacre store (later just Longacre), which boasted a Tiffany-style sign brought from Europe. Also visible is the O. C. Shepard feed store. Shepard, who also owned a mill, sold flour, grain, and seeds here. He had a large scale in the store and allowed children to weigh themselves. (Courtesy of MCHS.)

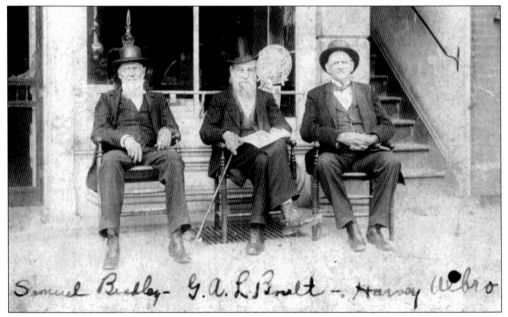

The three gentlemen taking their ease out of doors on a pleasant day are, from left to right, Samuel Bradley, G. A. Boult, and Harvey Albro, all prominent citizens of the era. They are seated in front of Albro's Drug Store, which opened in 1876 on the corner of Washington and Court Streets. Albro was a member of the board of directors of the Old Phoenix National Bank. (Courtesy of MCHS.)

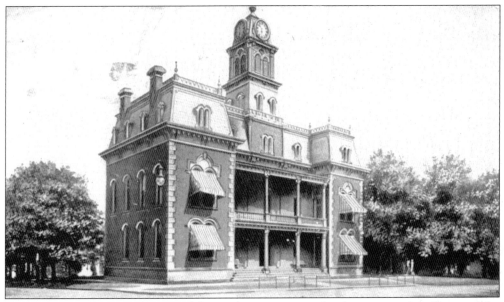

Due to the growth in population and the resulting increase in legal activity in the village and the county, the Medina County commissioners expanded the courthouse in 1873. New north and south wings enfolded the 1841 building. A two-story porch supported by cast-iron Corinthian columns was added, as well as a mansard roof, topped by a belfry with a clock tower and a 1,000 pound bell. The French Second Empire style of the addition blended well with the new Victorian architecture on the square. (Courtesy of CDC.)

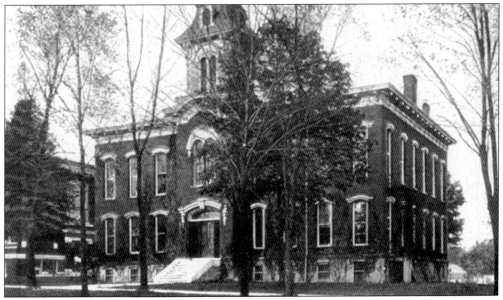

In addition to rebuilding the square, the citizens of Medina gave thought to the need for a new public school. A $20,000 bond was approved by the village council, and a handsome, two-story brick building with a belfry and a spire was completed in 1872. This building housed all the students, from the primary grades though high school. Two unused rooms were rented to Carver's Normal School, a college-level training program for teachers. This building was torn down in 1950 to make way for an addition to the Garfield School. (Courtesy of MCHS.)

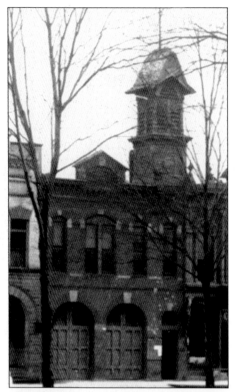

Despite two devastating fires, the village still had no organized fire department. In February 1877, a third fire broke out in the Empire Block on the northwest side of the square, and three buildings were damaged. One year later, the Medina Town Hall and Engine House was completed. This building also served as Medina's city hall until the early 1950s. (Courtesy of MCHS.)

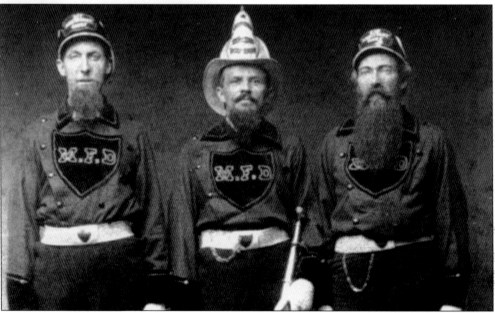

In 1879, the Medina Fire Department consisted of these three volunteers: (from left to right) Orlo M. Jackson, cabinet maker; E. F. Brenner, harness maker; and Sam Scott, sheriff. Jackson was one of the first volunteers to join the newly formed fire department. A Civil War veteran, he served in the 103rd Ohio Volunteer Infantry and returned home with impaired health. In 1868, he married Addie Brainard Paull, a widow with a millinery business. (Courtesy of MCHS.)

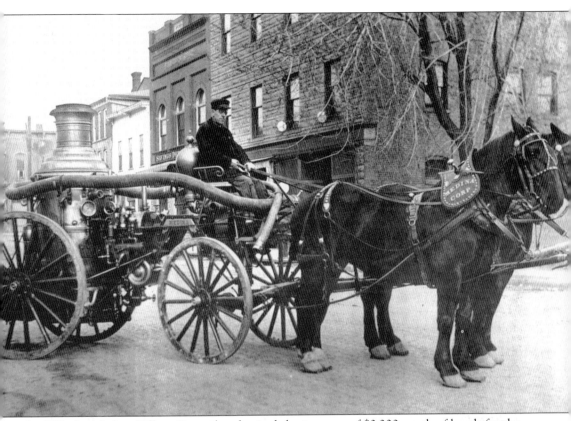

In 1877, the Medina Village Council authorized the issuance of $3,000 worth of bonds for the purpose of buying a fire engine. A two horse engine, No. 4 Silsby Steam fire engine was purchased from its manufacturer in Seneca Falls, New York. According to the local newspaper, the *Gazette*, an exhibition was staged for the village: "The court house bell was tapped, the Hunt's delivery horses were hitched to the engine, the fire started in the furnace, and the machine was driven around the square. At the courthouse reservoir, the suction cup was put into the cistern, the hose coupled on, and the water was thrown from two pipes in precisely eight minutes." It was a far cry from the bucket brigades of the recent past. The No. 4 Silsby Steam fire engine was decommissioned in 1919 and sold at auction for $350. (Courtesy of MCHS.)

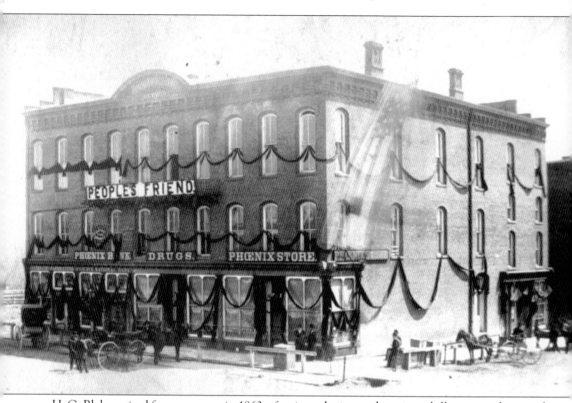

H. G. Blake retired from congress in 1863, after introducing and passing a bill creating the postal money order system, which is still in use to this day. When he returned to Medina, he served as mayor, editor of the *Gazette*, and was instrumental in bringing the railroad to the village. Under his guidance, the Phoenix Bank was chartered as a national bank in 1873. After a period of severe illness, Blake died on April 16, 1876, a few days short of his 57th birthday. Medina mourned Blake's death. All the buildings on Public Square were draped in black, and a banner fluttered from the balcony of his newly erected Phoenix Block with the words, "People's Friend." (Courtesy of MCHS.)

Four

THE GILDED AGE

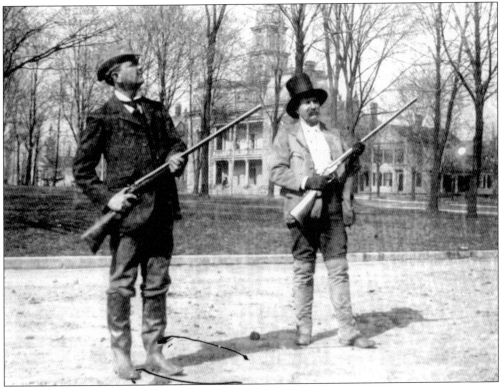

This photograph found in an old album is titled *Captains of the Crow Hunt*. The gentlemen are Charles Wightman (left) and Ben Wells (right). The annual crow hunt was a sporting event with teams vying for the honor of killing the most crows. Because the street is not paved, the photograph was probably taken in the early 1890s. (Courtesy of MCHS.)

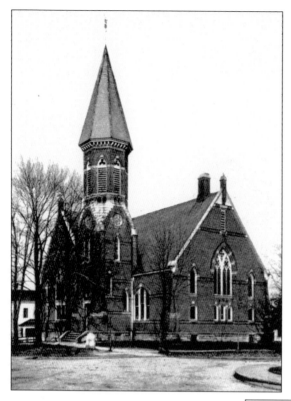

The United Church of Christ was dedicated on May 4, 1882. It replaced the Old Brick Church of 1832. This congregation went through a difficult period beginning in 1851, when a group of members withdrew over the slavery question and worshipped in a building nearby. After the conclusion of the Civil War, the congregation reunited. (Courtesy of CDC.)

This late–Gothic Revival structure of St. Paul's Episcopal Church was completed in 1884 and is on the National Register of Historic Places. It boasts a number of splendid stained-glass windows donated by such early Medina families as the Bronsons, Canfields, Thayers, and Parkers. (Courtesy of CDC.)

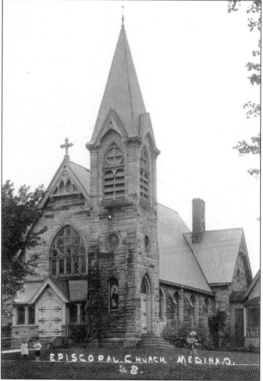

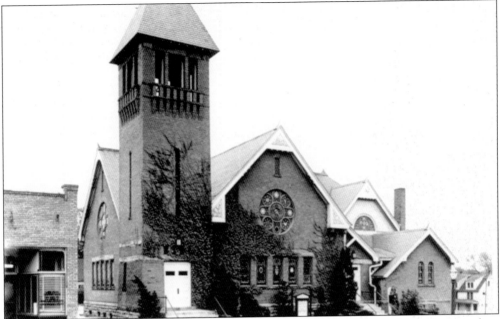

The history of the Methodist congregation in Medina dates back to 1837, although traveling preachers came to the area as early as 1817. This building was erected in 1897 after a fire destroyed the 1860 structure. According to *Historical Highlights* a book complied by the Medina High School class of 1966, it was called "the most beautiful fire in Medina's history" because the biblical scene painted on the wall behind the pulpit was illuminated by flames as the building burned. (Courtesy of CDC.)

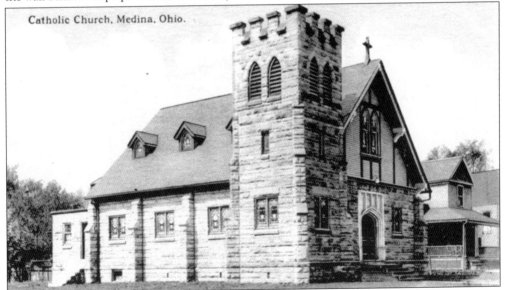

The founding of St. Francis Xavier parish goes back to 1860, when Rev. Fr. John Van Der Bock visited Catholic families in Medina village. The cornerstone for this building was laid on September 22, 1907, in the presence of one of the largest crowds ever to assemble in Medina. Close to 3,000 visitors came by train from Akron and Cleveland and hundreds more arrived by carriage from Wooster, Berea, and Elyria. The congregation moved to a larger church on East Washington Street in 1951. (Courtesy of CDC.)

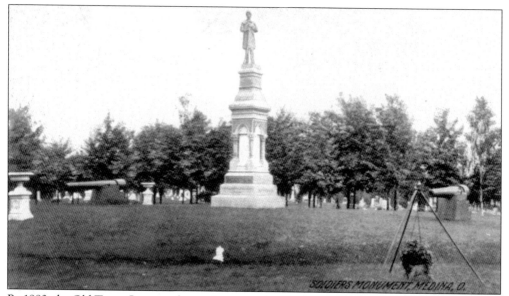

By 1883, the Old Town Graveyard near the square had become crowded and a new burial ground was needed. A committee purchased Chamberlain's cow pasture, which was 34 acres in size, for $3,400. At the time of the purchase, the site had a small meadow in front with ravines and gullies in the rear. The trustees of the new cemetery converted the meadow into a park and created the burial ground in the wooded section in the back. The soldiers' monument was dedicated on November 23, 1888, in a stirring ceremony attended by many veterans of the Civil War. (Courtesy of the CDC.)

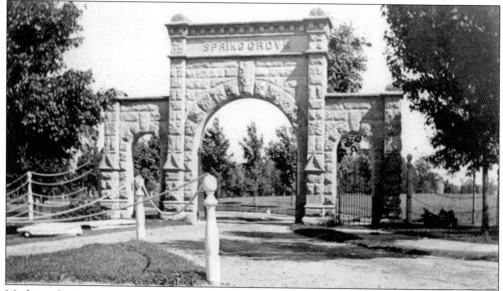

Marking the entrance to Spring Grove Cemetery is this beautiful sandstone archway, designed by architects Stentz and Sheppard of Cleveland and built by George Gruninger of Medina in 1892. It is composed of a main arch and two flanking pedestrian entrances. The Ladies' Cemetery Association raised the money necessary to pay for the entrance by running the dining hall at the county fair for several years. Spring Grove Cemetery was placed on the National Register of Historic Places in 2006. (Courtesy of MCHS.)

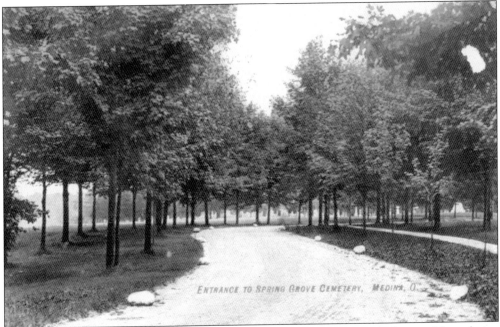

Spring Grove Cemetery was influenced by the rural cemetery movement, which gained favor during the Civil War when Pres. Abraham Lincoln dedicated Gettysburg Cemetery as a monument to those who died on the nearby battlefield. Cemeteries became landscaped parks with ponds and curving paths, like the one shown in this postcard. In the late 19th and early 20th centuries, Spring Grove Cemetery was a popular place for Sunday afternoon carriage rides. (Courtesy of CDC.)

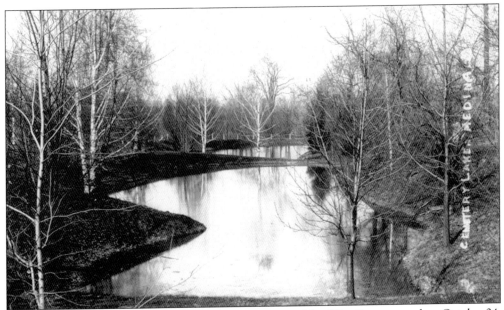

The Ladies' Cemetery Association raised $230 to create a lake. The *Gazette* stated on October 24, 1884, "The lake in Spring Grove Cemetery is now full of water. The banks all around have been sodded and the lower spring has been walled up . . . A rustic bridge is to be thrown across the ravine just above the spring. The ride through the grounds now is fine." (Courtesy of CDC.)

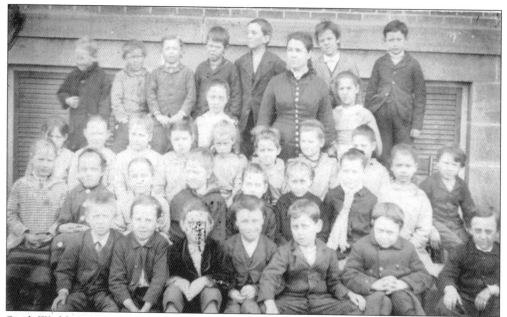

Sarah Washburn Pritchard stands in the midst of her third-grade class in front of the Lincoln School in 1880. The back of the photograph has this inscription, "Picture taken by a traveling artist from Cleveland and a present to the teacher from him. Taken on a warm sunny day in February." Pritchard herself was a product of the Medina schools. She attended the one-room schoolhouse called South School, located on the corner of South Court and Lafayette Streets and was a member of the first class to graduate from the newly built Lincoln School in 1876. (Courtesy of MCHS.)

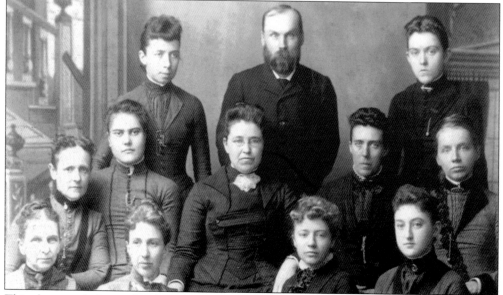

This photograph depicts Pritchard (in the center) taken 10 years later in 1890. She is surrounded by teachers from the village schools. They are, from left to right, (first row) Delia Allen, Pauline Shepard, Amy Collins, and Frannie Kennan; (second row) Lelia Barker, Cora Eddy, Sarah Washburn Pritchard, Sarah Smith, and Frannie Thompson; (third row) Clara Steeb, Professor J. R. Kennan, and Lena Sanders. (Courtesy of MCHS.)

Electric lighting came to Public Square sometime in the 1890s. It first consisted of four lights, one on each corner of the square. In this photograph, Eugene Edwards, custodian of the Lincoln School, poses with his broom and a children's playhouse next to one of those arc lights. (Courtesy of MCHS.)

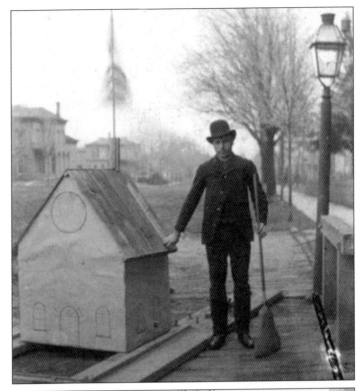

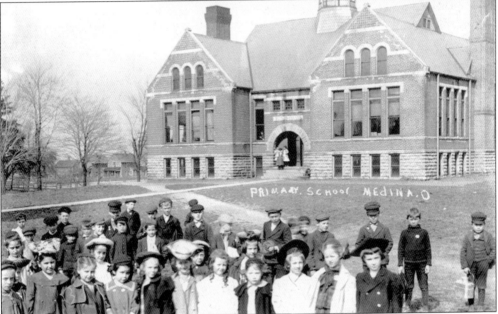

By the last decade of the 19th century, student enrollment in the village schools had increased so much that the Lincoln School was filled to capacity. A school bond issue was approved, and in 1891, the Medina Primary School opened. The school consisted of four large rooms, each with a capacity for 50 students, and was located on North Broadway Street where the County Administration Building now stands. It was torn down in 1923. (Courtesy of David Kellogg.)

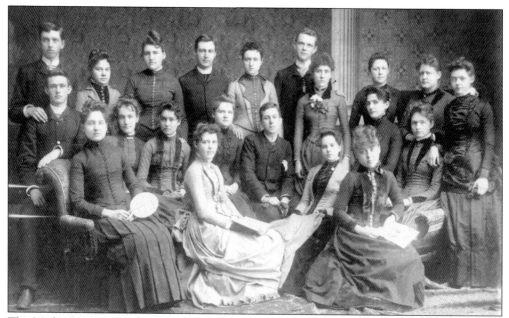

The Medina High School class of 1888 included two future teachers, Mary Wheatley and Belle Warner. There were only five males in the class, which was not uncommon in that era. Fewer males graduated from high school because by the age of 18 many had quit to work on the family farm or to seek employment elsewhere. The ones who remained usually came from affluent families. The students are, in no particular order, Orlen Ferriman, Irving Fenn, Don Goodwin, Harry Lewis, Dwight Shepard, Helen Foskett, Belle Holben, Genie Andrews, Julia Logan, Mary Logan, Belle Warner, Minnie Gayer, Mary Wheatley, Lucy Kennedy, Emily Blakeslee, Alice Dealing, Millie Gray, Elizabeth Whipple, Alice Huddleston, and Mary Eunice Shepard Griesinger. (Courtesy of MCHS.)

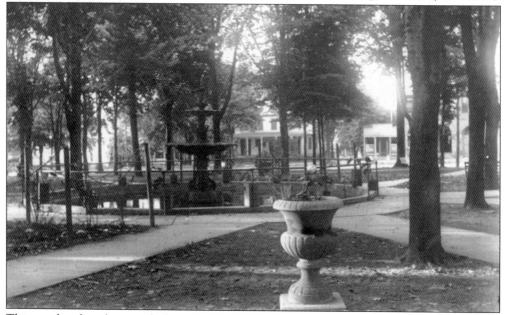

This pond with a classic-style fountain stood in the center of Public Square Park from the late 19th century until 1914. (Courtesy of CDC.)

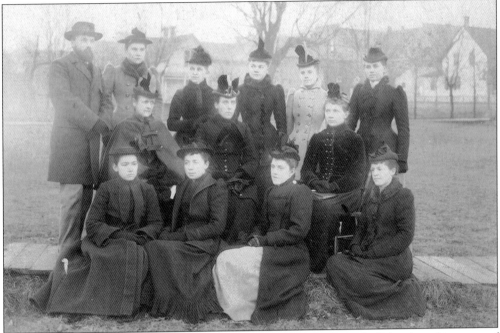

This group of teachers from the late 1890s stands beside the old Lincoln School on the corner of South Broadway Street and East Smith Road. The ladies are, from left to right, (first row, seated) Lecia Miller, Norma Collins, Grace Cherboneau, and Belle Warner; (second row) Lena Sanders, Mary Wheatley, and Mary Logan; (third row) superintendent J. R. Kennan, Sarah Smith, Delia Alden, Frannie Thompson, Lelia Barker, and Clara Steeb. (Courtesy of MCHS.)

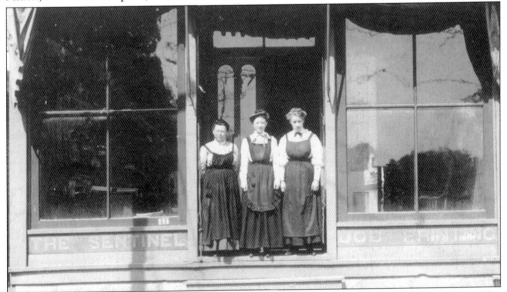

Three employees of the *Sentinel* stand on the steps of the offices on North Court Street. The paper was founded in 1883 and outlasted three other newspapers: the *Medina News*, the *Medina Democrat*, and the *Medina Republican*. Sam Brainard, a legendary newspaperman of the era, was editor when the paper was purchased by the *Gazette* in 1959. Although elderly, Brainard continued to write a column for the *Gazette* well into the 1960s. (Courtesy of Elmer and Betty Zarney.)

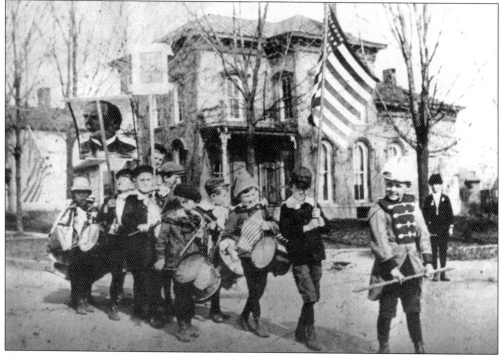

This photograph of a children's band carrying a banner with a portrait of William McKinley might have been taken on the day the presidential candidate spoke from the balcony of the Phoenix National Bank in the fall of 1896. (Courtesy of CDC.)

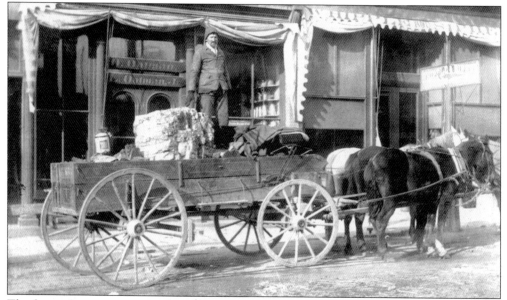

The horse-drawn wagon stands in front of two well-known businesses of late-19th-century Medina. The Oatman Brothers maintained a stove and tinware business. The man standing in the wagon is probably one of the gang of men that they employed to go to homes of customers and do slate or tin roofing. Whipple and Sipher at the far right was a leading purveyor of groceries and crockery. (Courtesy of MCHS.)

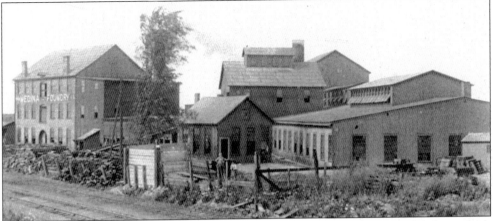

Pictured here is the Medina Foundry Company, one of the earliest industries in Medina, which was started in the 1860s by Alfred C. Webber and Alvah Washburn. They manufactured hollow castings. Ownership changed several times over the next 80 years, and eventually, in 1943, it became the Henry Furnace Company, which manufactured coal furnaces until 1954. (Courtesy of Elmer and Betty Zarney.)

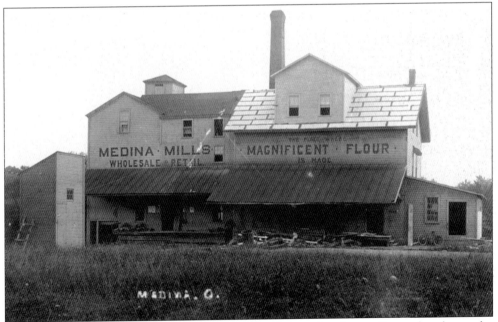

This mill was organized in 1872 by Oliver Collins Shepard and manufactured such popular brands of flour as the Magnificent, the Splendid, and Grandfather's Old Wheat. The Shepard family also maintained a feed store on the west side of the square, where they sold flour, seed, grain, baled hay, and straw. (Courtesy of Elmer and Betty Zarney.)

Louise Neil celebrated her sixth birthday on August 6, 1891, with family and friends. Louise was the daughter of the owner and editor of the *Medina County Gazette-News*, Charles Neil, and the story appeared in the family newspaper with the headline, "Jolly Juveniles At A Birthday Party: Army of Little Home Tyrants Making Merry Over the Birthday of One of Their Playmates." Charles Neil was a native of New York City and worked for a number of newspapers, including the *Cleveland Leader*, before he came to Medina and was elected clerk of Medina County. Charles purchased the *Gazette* after the death of the former owner, Captain Greene, and in 1895, built the Romanesque-style Gazette building on the south side of Public Square. He did not live long enough to enjoy it. He died of apoplexy on December 14, 1896, leaving a wife and four children. At her husband's death, Nellie Crossley Neil assumed management of the paper. (Courtesy of MCHS.)

Five

A NEW CENTURY DAWNS

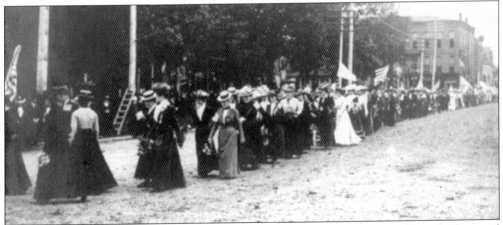

In 1912, the Women's Suffrage Party of Cleveland roared into Medina and marched around the square, armed with banners and fiery purpose. Woman suffrage was a burning issue in the early 1900s, and woman's rights leaders advocated marches, picketing, and other active forms of protest. After the rally, Medina women formed their own suffrage organization with Pauline Shepard, a teacher, as president. (Courtesy of MCHS.)

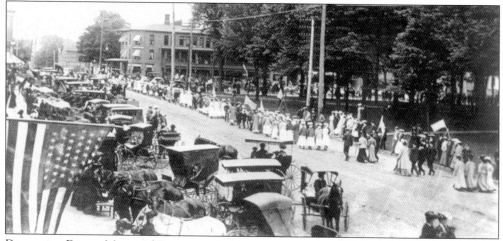

Decoration Day, as Memorial Day was called in years past, was celebrated with great enthusiasm in Medina. This photograph from the early 1900s shows the west side of the square with groups of school children carrying American flags and banners and marching toward the American Hotel, which stood on the northwest corner of the square. (Courtesy of David Kellogg.)

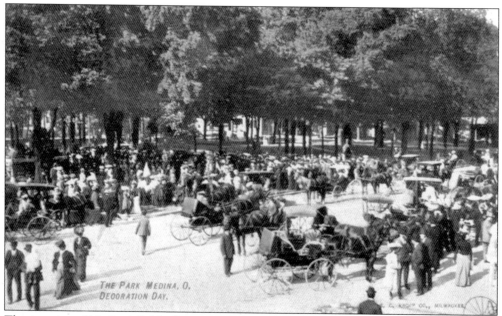

This is a view of Medina's Public Square Park seen from the west side of the square. People drove in from all over the county to watch the Decoration Day parade. The magnificent elm trees, planted during the Civil War, provided a lush canopy over the park in this era. (Courtesy of David Kellogg.)

The Interurban Electric, part of the Cleveland, Southwestern and Columbus Railway, reached Medina in 1899 and made travel to nearby towns and cities convenient and inexpensive. For example, the two-hour trip from Medina to Cleveland cost 50¢. This remained a popular way to travel until the increasing popularity of the automobile drove the Interurban Electric out of business. (Courtesy of MCHS.)

This postcard, dated 1907, shows the interurban tracks along West Liberty Street, where they curved west from North Court Street. Medina County Creamery, on the left, is receiving a shipment of milk. Despite the popularity of the interurban, a horse-drawn buggy was still the primary means of transportation in the village. (Courtesy of MCHS.)

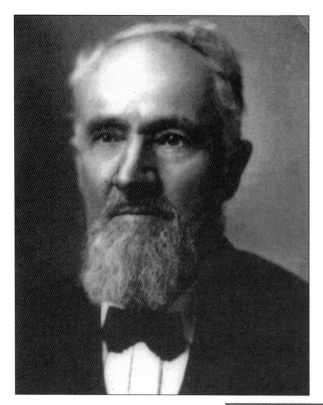

In 1905 Franklin Sylvester, a wealthy cattle dealer from Granger Township was asked by Judge Amos Webber if he would like to become immortal. Sylvester wondered how that might happen. Webber suggested that he build a library. Sylvester agreed and acquired a lot from Judge Fremont O. Phillips on the southeast corner of the square for that purpose. The only problem was that Phillips's house was still standing on it. The house was later moved to a site on North Broadway Street to make room for the library. (Courtesy of the Medina County Public Library.)

Fremont Orestes Phillips was a leading citizen in early-20th-century Medina, a self-made man who started out as a teacher and eventually became a lawyer, mayor of the village, U.S. congressman, and probate judge. At the time that Phillips sold the lot to Sylvester, the Phillips home was one of the most magnificent in the village, white-pillared and modeled after the White House. It had been built in 1833 by a wealthy merchant named David King. When electricity came to Medina, the power plant was a short distance from the house, and the switch to power the four arc lights on the square was placed in Phillips's living room. He decided what time to turn on the switch to light up the square. (Courtesy of Drew Phillips.)

This is a photograph of Fremont O. Phillips's oldest daughter, Florence, at the dawn of the 20th century when she lived in the big white house on Public Square. She later taught Latin and history at Medina High School for 37 years and traveled around the world during her summer vacations. (Courtesy of Drew Phillips.)

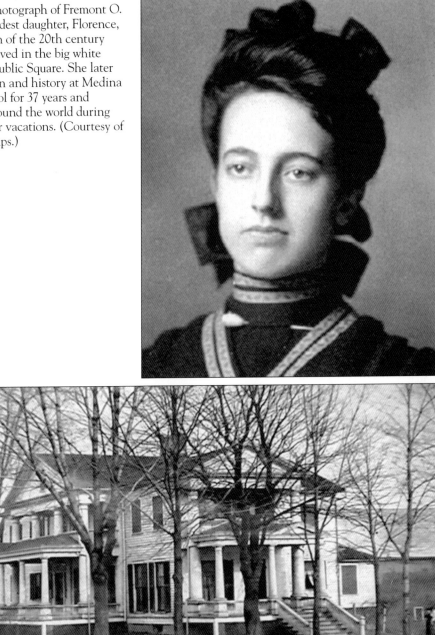

In a talk she gave to the Medina County Historical Society in 1952, Florence Phillips described the experience of moving the large house half a mile north into the country. She wrote, "The second week in June we prepared to move. The back part was cut first and taken onto Broadway Street where it was turned and headed north. The main part, 72 feet across, was then taken and in the same way it was turned into the street. Small rollers on railroad ties were used to move the building. In five days time it was up and on the new foundation." (Courtesy of MCHS.)

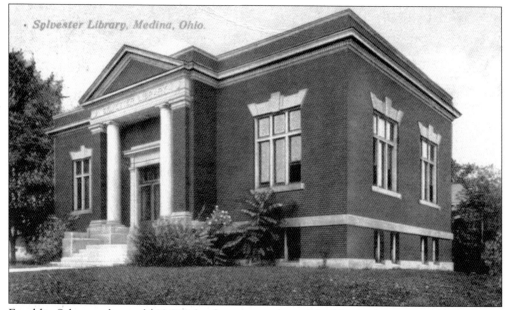

Franklin Sylvester donated $10,000 for the construction of the library that was to bear his name and stipulated in his will that the property might never be used for anything else. A public library did exist in Medina as early as 1877, when a group of citizens organized the Medina Library Association. The collection of books was held in Meora Andrew's jewelry store because the association could not afford to rent a room. This library was supported by $1 membership dues and proceeds from chicken dinners. Sylvester's bequest changed all that. (Courtesy of CDC.)

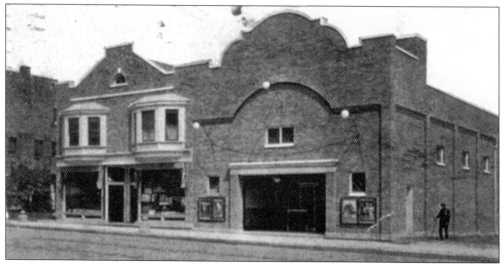

Silent movies came to Medina in 1913 with the opening of the luxurious Princess Theater on the northeast corner of the square. The theater was heated by steam heat, lit by "sixty brilliant lights" which framed the stage, and offered the latest technology with "Edison and Powers electrical picture machines." An admission of 25¢ was charged for the silent movies, which played every evening. On weekends, vaudeville comedians and singers also appeared. Tom Mix, the legendary hero of silent films once visited the theater in person, accompanied by his horse. (Courtesy of MCHS.)

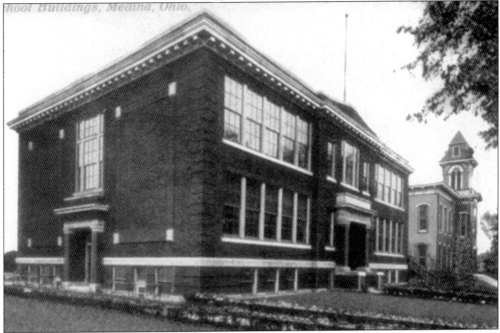

The village grew during the early years of the 20th century, and student enrollment increased so much that another school was needed to house the primary grades. In the fall of 1912, a new 10-room structure was built just north of the Lincoln School (visible at the far right), separated by a narrow walkway. It was called the Garfield School in honor of Ohio-born James A. Garfield, 20th president of the United States. (Courtesy of MCHS.)

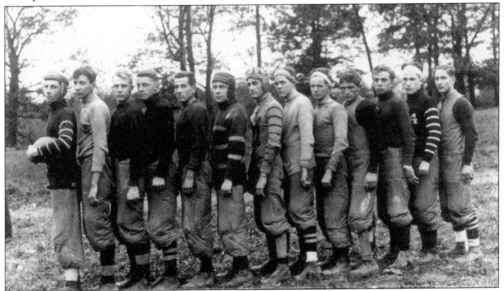

The Medina High School football team had an unusually successful season in the fall of 1912. According to a *Gazette* story on October 25, the team "trimmed the Wooster eleven on the Medina fairgrounds last Saturday to the tune of 34-0. The Medina boys played a fast, snappy game completely outlasting their opponents. It was the last game that Medina . . . played. A fair crowd was in attendance." (Courtesy of MCHS.)

Little did the teacher or any of the students in the first grade class, seated on the steps of Medina Primary School in 1901, dream that in their midsts sat the future founder of an international corporation. One of the little boys in this crowd is Vernon Stouffer of hotel and food packaging fame. Stouffer left Medina at a young age. (Courtesy of MCHS.)

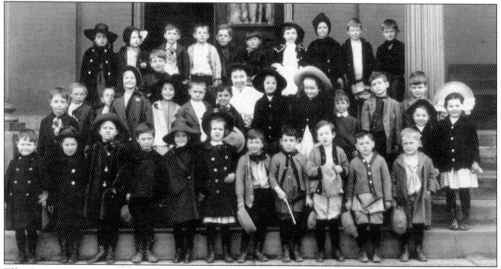

Ella Canavan poses on the courthouse steps with her kindergarten class around 1910. Miss Ella, as she was affectionately known, was an 1896 graduate of Medina High School. While still a student at Oberlin College, she began her career as an assistant kindergarten teacher in Medina in a private class organized by the Medina Kindergarten Association in 1897. When Canavan graduated from college, she took over this class and continued to teach for five years without pay, until it became part of the Medina schools. Canavan played John Phillip Sousa marches on a wind-up Victrola as her students marched in pairs to and from class. She retired in 1945. A new elementary school was named in her honor in 1960. (Courtesy of MCHS.)

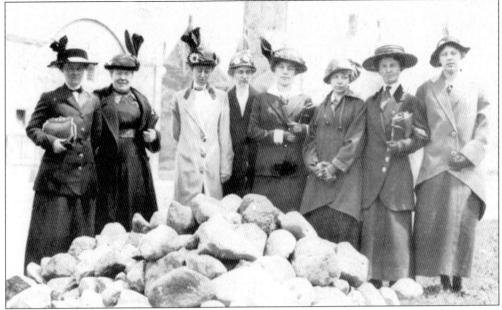

This photograph shows an impressive pile of rocks collected by the pupils of Garfield School on Arbor Day, April 14, 1914, at the request of the Medina Improvement Association. The rocks were intended for the construction of a fountain in the center of the park. The teachers are, from left to right, Evelyn Flange, fourth grade; Clara Wheatley, eighth grade; Pearl Drake, seventh grade; Millie Tubbs, third grade; Clara Warner, fifth grade; Nell Batton, sixth grade; Lena Johnson, seventh grade; and Helen Hobart, fourth and fifth grades. (Courtesy of MCHS.)

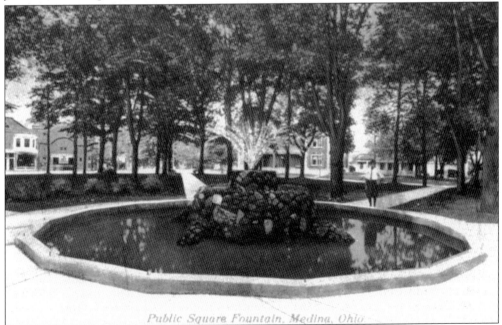

Public Square Fountain, Medina, Ohio

The new fountain constructed of rocks was completed in the summer of 1914 by William Stelzer. It replaced a classical fountain topped by a statue and surrounded by balustrades, which had stood there since the 1890s. It is not known why this change was made. (Courtesy of MCHS.)

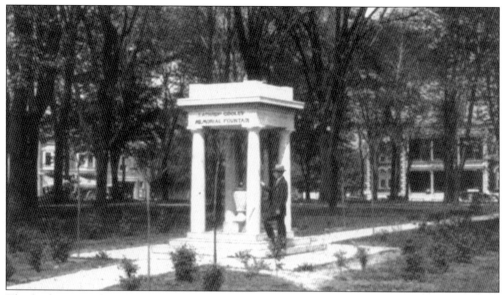

The Lathrop Cooley fountain located on the west side of Public Square Park was the gift of Mrs. Lathrop Cooley in memory of her husband, who served the Disciple Church as pastor from 1889 to 1892. The Cooleys were both involved in the temperance movement and believed in the virtues of clean drinking water. (Courtesy of MCHS.)

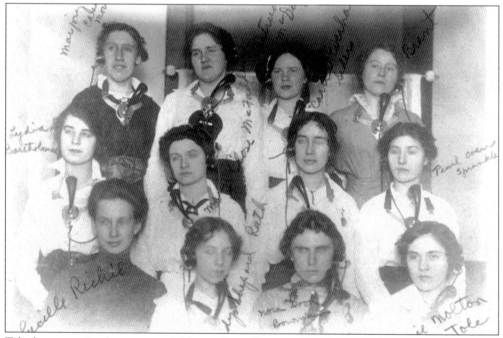

Telephone service became available in the village in about 1900. The Medina Telephone Company bought out its rival, the Bell Telephone Company, and established offices in the International Order of Odd Fellows hall on the north side of the square. In place of directories, each subscriber received a card that listed everyone with a telephone. By 1914 when this photograph was taken, the telephone service had expanded enough that a small telephone book was published. (Courtesy of MCHS.)

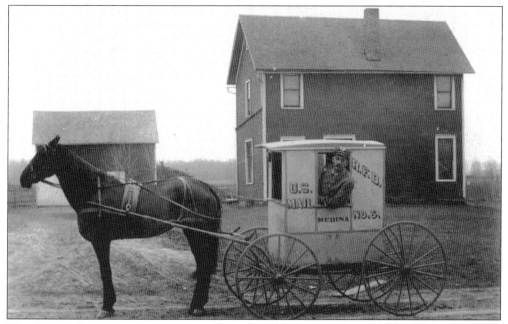

The first mail carrier service was established in 1901 when five rural routes were created. Two city routes were started in 1907 to serve a population of 2,500. The mailman in his horse-drawn conveyance was always a welcome sight, as indicated by this postcard sent as a Christmas greeting on December 14, 1907. (Courtesy of MCHS.)

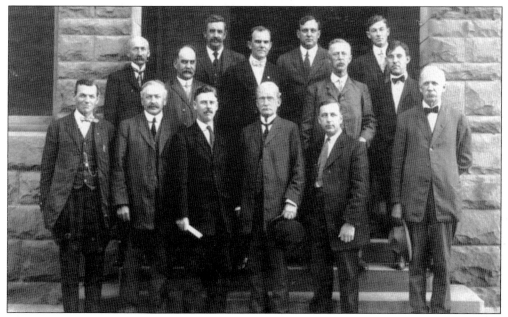

This is a photograph of the executive committee of the Medina County YMCA, which was organized in 1907 by 12 men. It was governed by a board of directors representing the various townships in the county. Identified only by their last names are, from left to right, (first row) unidentified, Etter, Garver, Everhard, Hawley, and Koppes; (second row) Yoder, Mattison, Lanham, Bostiwck, and Root; (third row) Derr, Boyden, and Giff. (Courtesy of MCHS.)

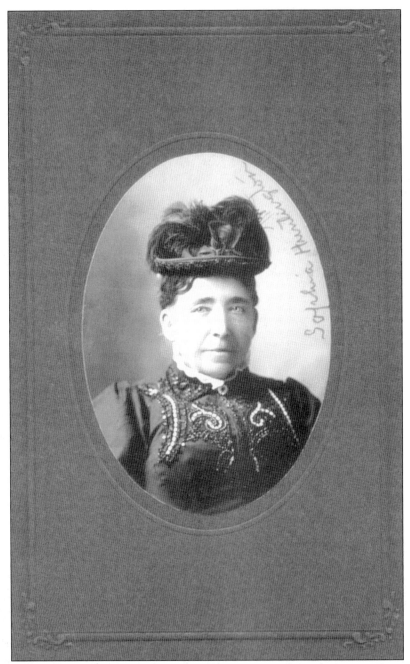

When Sophia Huntington Parker died in 1903, alone in the kitchen of her farmhouse, she left an 86-acre farm. This farm was one of Medina's early pioneer homesteads and was located on what is now North Huntington Street. Parker had been born there in 1837, the oldest of five children. She left no direct heirs. She and her deceased husband, William Parker, had been childless and her four siblings and their children had also passed away. In her will, Sophia stipulated that the farm should go to any group that would build and maintain a home for aged women. The Pythian Sisters accepted the offer just before the condition in Parker's will expired. (Courtesy of MCHS.)

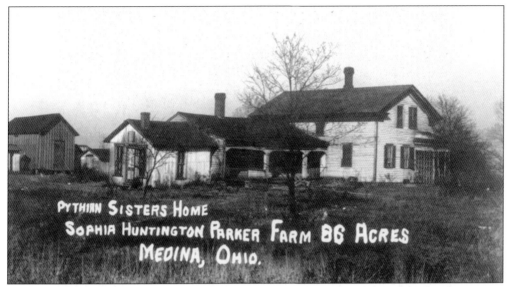

Peter Huntington, the father of Sophia Huntington Parker, had come to Ohio from Norwich, Connecticut, and her mother, Jane Simmons, came from a "wealthy and aristocratic family in New York." On a visit to Ohio, Simmons met her future husband, then married him, and in 1835, they moved to a log cabin on this farm, which was then referred to as a "stump lot." The Huntington family built this farmhouse soon afterward. (Courtesy of CDC.)

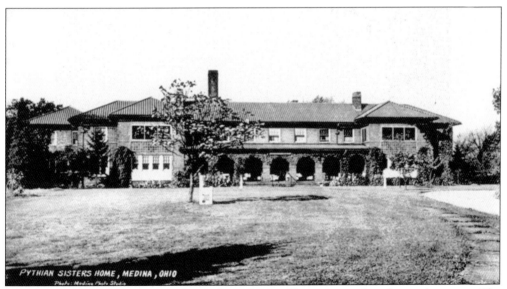

In 1914, construction began on the Pythian Sisters Home as a refuge for aged women. The dedication ceremonies took place on June 12, 1916. Originally livestock were raised and crops were grown on the grounds of the home, but changes in Medina's zoning laws curtailed that practice. The facility is now called the Sophia Huntington Parker Nursing Home. (Courtesy CDC.)

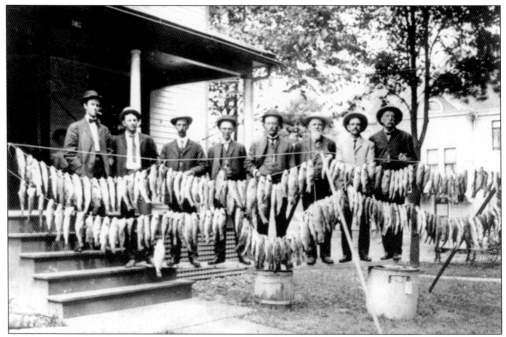

Eight of Medina's most prominent citizens display their impressive day's catch in this photograph, taken about 1910. They are, from left to right, Arthur Van Epp, Seth J. Swain, Judge Fremont O. Phillips, Frank T. Burnham, Dr. W. B. Croft, Ephraim Brenner, John Schmittle, and S. G. Foote. (Courtesy of MCHS.)

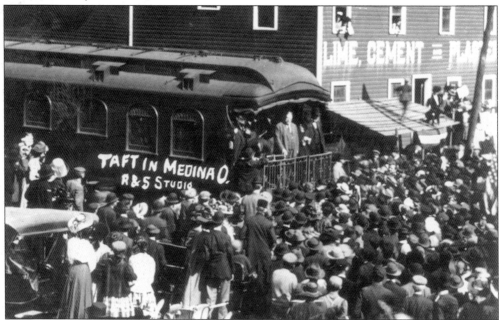

In 1907, presidential candidate William Howard Taft barnstormed through Medina, speaking to the assembled crowd from the back of a train. The crowd looks enthusiastic but Taft does not. He disliked campaigning and said that running for president was "the most uncomfortable four months of my life." (Courtesy of David Kellogg.)

Six

FAMILY SAGAS, PART I

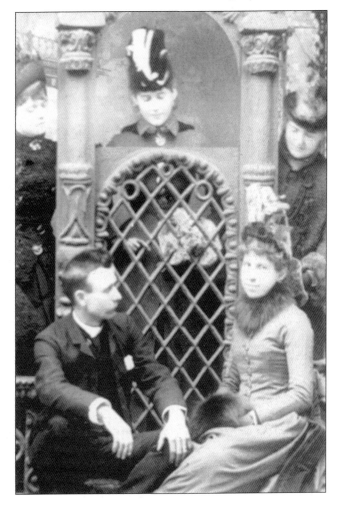

This photograph was taken in December 1896 by I. F. Hawkins, one of Medina's most popular photographers. Standing in the center is Bessie McDowell, granddaughter of H. G. Blake. Seated are her life-long best friend, Mary Eunice Shepard Griesinger and Mary's new husband, Christian Griesinger. McDowell and Griesinger were daughters of affluent, privileged families in Medina. They were called Auntie Bess and Auntie Mary by each other's children and are buried close to each other in Spring Grove Cemetery. (Courtesy of Drew Phillips.)

Elizabeth Blake McDowell, oldest daughter of H. G. Blake, is seen here with two great-grandchildren, Betsy and Charles Hewes Phillips in 1923. Elizabeth was born in 1842 in one of the first frame houses built in the village of Medina. In the 1850s, her father was involved in the Underground Railroad. Elizabeth, then a young child, noticed that her mother would occasionally make exceptionally large meals—more than enough for their family of four. Elizabeth kept asking questions, and finally H. G. explained to her what he was doing and cautioned her to be discreet. Just to be on the safe side, however, whenever runaway slaves were hidden in the house, the two daughters were kept home from school. During the first years of the Civil War, H. G. was a U.S. congressman and Elizabeth lived with him in Washington. She married Lt. Robert M. McDowell in 1863. (Courtesy of Betsy Phillips Whitmore.)

When the Civil War ended, Elizabeth and Robert returned to Medina. Elizabeth's younger sister, Helen, married Robert's brother O. H. in 1866, and H. G. built these twin Italianate Victorian houses for his daughters. Both brothers joined H. G. in a variety of business ventures, and after H. G.'s death, Robert became president of the Old Phoenix National Bank. The houses are seen here in a 1909 postcard. (Courtesy of MCHS.)

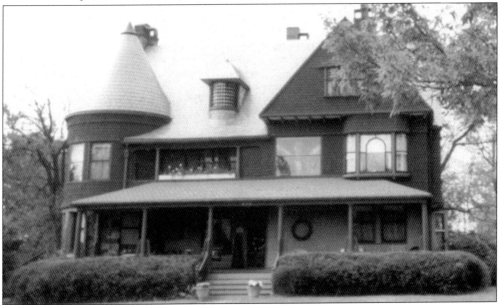

In 1890, Elizabeth and Robert McDowell built this Queen Anne–style home on Prospect Street for $10,000—a huge sum of money at the time. The large, opulent house was the setting for four weddings and countless family celebrations. Grandchildren remembered Christmas celebrations as being especially festive. Every Christmas Eve, the five McDowell children gathered their families and arrived by sleigh or automobile to spend a week feasting and playing games. One grandson recalled bringing along the family cow to insure a fresh supply of milk for the young children. (Courtesy of David Brown.)

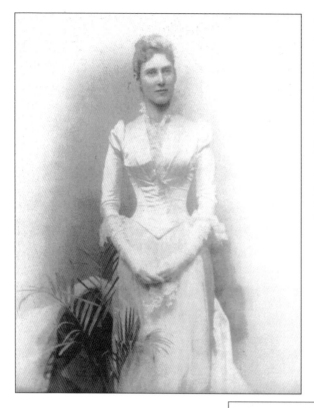

This is Bessie McDowell on her wedding day, January 30, 1890. Born in 1865 to Robert and Elizabeth McDowell, she graduated from Medina High School in 1882 and attended the New England Conservatory of Music in Boston. While visiting friends in Annapolis, she met Ens. Charles Hinman Hewes of the United States Naval Academy. Their wedding was the social event of the season, but their happiness was short-lived. (Courtesy of Drew Phillips.)

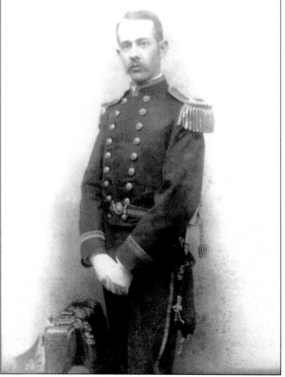

Charles Hinman Hewes strikes a dashing pose on the day of his wedding to Bessie McDowell. A native of West Chester, Pennsylvania, he graduated first in his class from the U.S. Naval Academy. After the wedding, the couple moved to Norfolk, where he was posted. Six weeks later he died of typhoid fever, never knowing that Bessie was newly pregnant with their child. Bessie never remarried. (Courtesy of Drew Phillips.)

Mary Eunice Shepard married Christian Griesinger on December 29, 1886. A member of the Medina High School class of 1882, she was the daughter of the wealthy gristmill owner, O. C. Shepard, and lived in the former H. G. Blake house on East Washington Street. She attended the New England Conservatory of Music in Boston with her friend Bessie Hewes and cofounded the Friday Afternoon Club with her. She preferred being the only Mary Griesinger in Medina and convinced her sister-in-law, also named Mary, to call herself May. (Courtesy of Drew Phillips.)

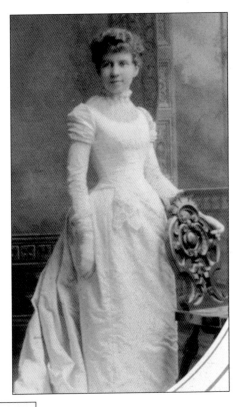

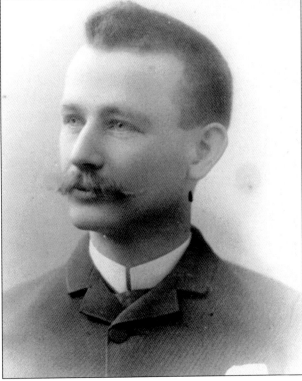

Christian Griesinger, seen here in his wedding finery, ran a shoe store—"the oldest, largest, most complete shoe store in northern Ohio"—with his younger brother, William. The son of a German immigrant, Griesinger began working in the family shoe store at the age of 15. The store remained a Medina institution until it was sold in 1954. (Courtesy of Drew Phillips.)

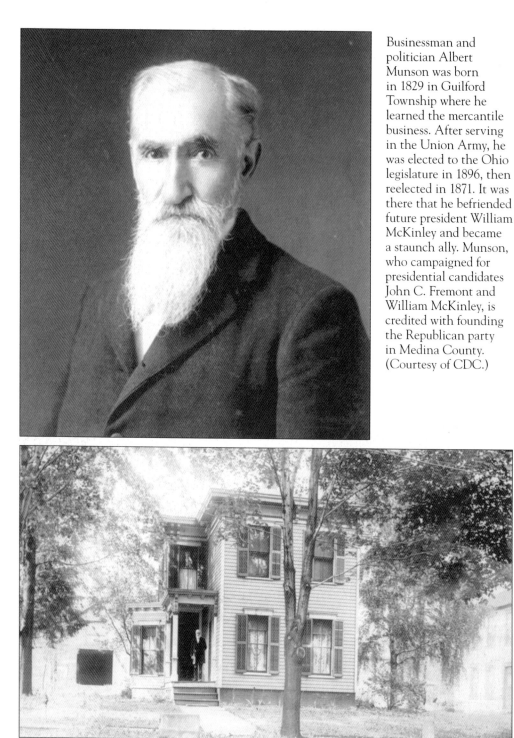

Businessman and politician Albert Munson was born in 1829 in Guilford Township where he learned the mercantile business. After serving in the Union Army, he was elected to the Ohio legislature in 1896, then reelected in 1871. It was there that he befriended future president William McKinley and became a staunch ally. Munson, who campaigned for presidential candidates John C. Fremont and William McKinley, is credited with founding the Republican party in Medina County. (Courtesy of CDC.)

In 1877, Munson became Medina County's probate judge and moved to Medina with his wife and two children. They lived in this Italianate Victorian house on East Washington Street. The house was given to the MCHS upon the death of Munson's daughter Cora in 1956. In 1985, it was acquired by the CDC and moved to 141 Prospect Street. (Courtesy of CDC.)

Albert Munson and his son Lyman operated a hardware store in this 1879 building on the south side of Public Square. The business, sometimes referred to as "Dad and I," occupied a large double store with a tin shop in the rear. In the early 1970s, an arcade was created in one half of the former hardware store. (Courtesy of CDC.)

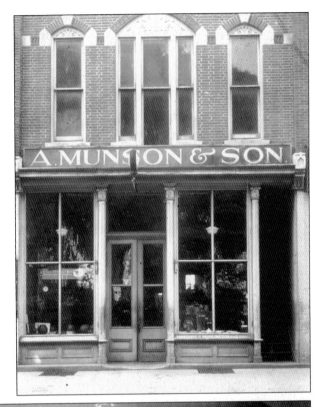

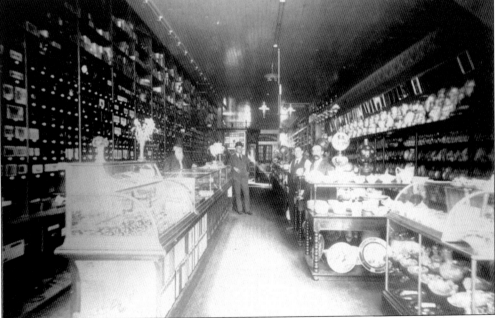

Here is a view of the interior of Munson's store in the early 19th century, stocked with a wide variety of goods. Not only did A. Munson and Son carry hardware but also "crockery ware, chinaware, lamps and everything necessary in that line to please the most fastidious." The bald gentleman with the handlebar mustache is Lyman Munson. (Courtesy of CDC.)

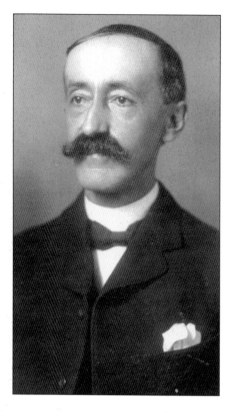

Lyman Munson was born in 1866. He attended the public or "common" school in Medina, graduated from Medina High School in 1881, and married Harriet Eastman. Munson died in his 30s. (Courtesy of CDC.)

Cora Munson was born in 1857 and taught school in Medina and several other communities. In 1901, at the age of 44, she married Charles Blakeslee, 32, director of St. Paul's Episcopal Church Boys Choir. She returned from the honeymoon alone and never lived with her husband. Only one friend was told the reason, and that friend never divulged it. (Courtesy of CDC.)

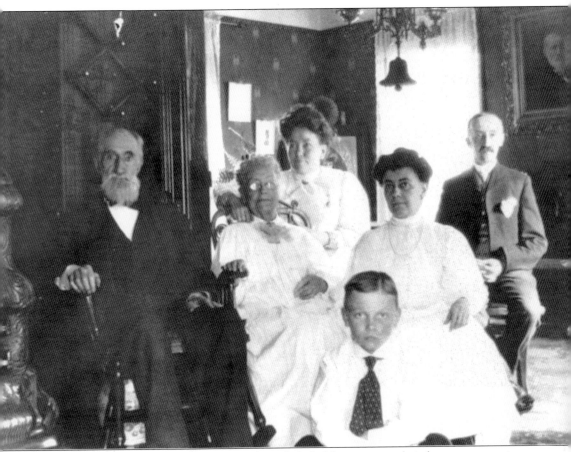

The Munsons were devout spiritualists and regularly held seances in their home, summoning spirits of departed relatives. Albert Munson, according to records kept by his daughter Cora, also communicated several times with the recently assassinated William McKinley, who was evidently still in transition and was having difficulty in adjusting to the spirit world. Munson sent letters describing these seances with the president to William's widow, Ida McKinley, but her doctor forbade her to read them because of her delicate condition. The letters were then burned. The spirits of Abraham Lincoln and James Garfield also paid their respects to Munson. (Courtesy of CDC.)

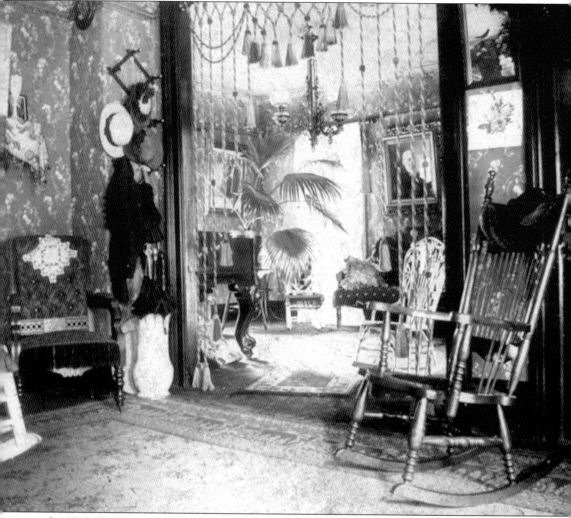

In 1913, Cora was the last remaining Munson. She lived alone in the house until her death in 1956 at the age of 99. She ran the hardware store for 25 years. A staunch Republican like her father, she kept campaign posters of all the Republican presidential candidates from James Garfield to Dwight Eisenhower in the window of the hardware store. During those years, she continued to set a place at the table for her parents and her brother, turning over their plates to indicate that they were with her in spirit. Seen here is Munson's parlor, devoid of everyone except perhaps spirits. (Courtesy of CDC.)

Amos Ives Root is known as the "father of modern beekeeping." The founder of the A. I. Root Company, a national leader in the manufacture of candles, he began his business by accident. One August day in 1865, as he sat in the window of his jewelry shop on the square, Root noticed a large swarm of bees outside. An employee offered to capture the swarm. Root offered the man a dollar—an entire day's wages. The employee returned with the bees in a box, and Root changed the direction of his life. Root purchased a book by a minister and amateur beekeeper named Lorenzo Langstroth, who had invented a moveable hive frame. Root immediately saw its advantages and in 1869, created an improved version of the Langstroth hive. His jewelry business soon took second place to his beekeeping business. (Courtesy of A. I. Root Company.)

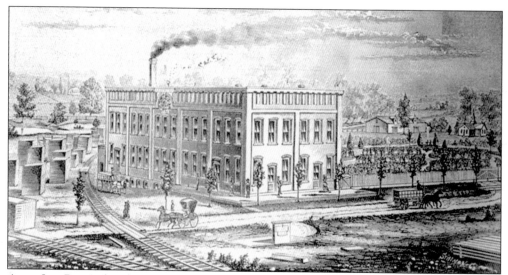

Amos Ives Root's shop burned down in the great fire of 1870. He rebuilt the shop but never felt entirely secure in that location. In 1878, he sold the jewelry business and purchased the old fairgrounds west of the square, adjacent to the newly constructed railroad tracks. He built a large, two-story facility. At the time, he did not possess sufficient funds to finance such a project, and the banks would not loan him the money. Root had started his own magazine, *Gleanings in Bee Culture*, which had gained a wide readership, and he described this dilemma in one issue. A reader from Canada boarded a train, came to Medina, and gave Root the money, which was repaid in due time. (Courtesy of A. I. Root Company.)

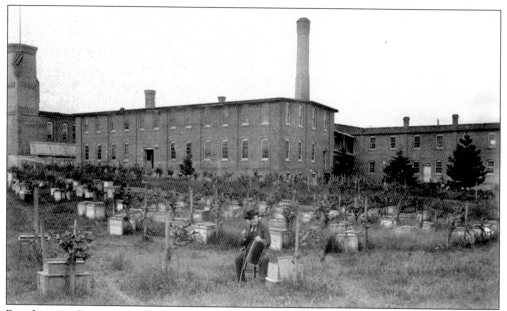

Rev. Lorenzo Langstroth, the inventor of the moveable hive frame, came to visit Root's plant. The time of the image is after 1883, because the size of the original Bee-Hive Works has doubled. Langstroth is surrounded by the beehives that he designed, and that Root built. Each box had a grapevine support because Root believed that bees needed shade in the summer. (Courtesy of A. I. Root Company.)

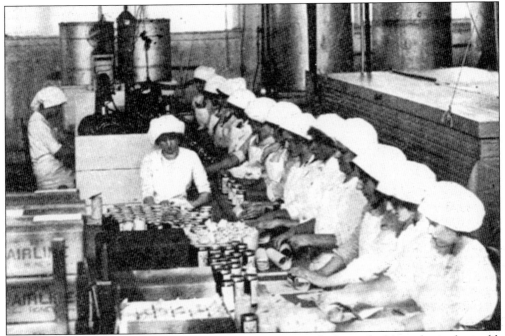

At the dawn of the 20th century, the A. I. Root Company was the largest honey-packer in the world. The company bought honey from beekeeper customers and bottled it, as this 1898 photograph demonstrates. In 1929, the A. I. Root Company began to manufacture beeswax candles, which had the advantage of not bending or wilting with heat. Customers for the candles include many Catholic churches, as well as the Vatican. (Courtesy of A. I. Root Company.)

This idyllic scene actually has a practical purpose. Root was endlessly inventive and pragmatic. He grew his own basswood trees, which provided wood for his manufactured honeycombs. The trees were also used as a nectar source for the bees and provided shade. The boxes under the trees contain queen-mating colonies. (Courtesy of A. I. Root Company.)

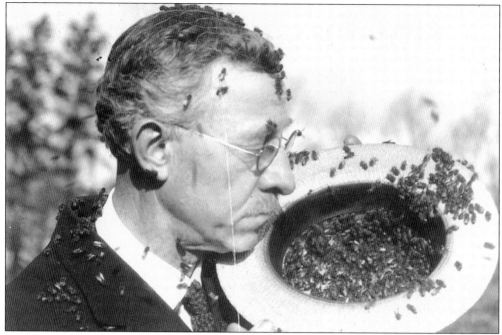

Ernest Root, a son of Amos, was the public relations expert of the company. He was the editor of *Gleanings in Bee Culture*, the publication started by his father, and spent a great deal of time on the road, speaking at beekeeping events and promoting the company and its products. Photographs like this one created excellent publicity for the company. (Courtesy of A. I. Root Company.)

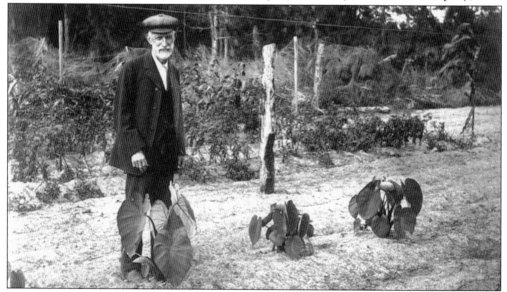

In 1894, Amos became ill with a lung infection. His doctor told him that he had less than a year to live. Amos gave the business over to his son Ernest and son-in-law John T. Calvert and turned to numerous hobbies. He bought a velocipede, which he rode daily and indulged in his passion for gardening. Amos developed and tested strains of vegetables and plants and experimented with recycling garbage by feeding table scraps to his carp. The family ate the carp, although one of his sons complained that the fish had an earthy taste. (Courtesy of A. I. Root Company.)

The First Published

Account of the

Wright Brothers Flight

by

Amos Ives Root

Reprinted from Gleanings in Bee Culture, 1905

THE A. I. ROOT COMPANY
Medina, Ohio

In 1903, Amos became interested in the experiments of Wilbur and Orville Wright and befriended the brothers. In the summer of 1904, he rented a pasture in central Ohio and watched the Wrights take off in their flying machine under motor power, circle the pasture, and return to the starting point. This was actually a more significant flight than the first one at Kitty Hawk, in which the Wrights were able to make their plane take off, but were unable to steer it. This time they had perfected the rudder, which gave them control, and were able to take off and land from the same spot. Root wrote about this ground-breaking flight in his magazine, *Gleanings in Bee Culture*. A copy of that issue is in the Smithsonian. (Courtesy of A. I. Root Company.)

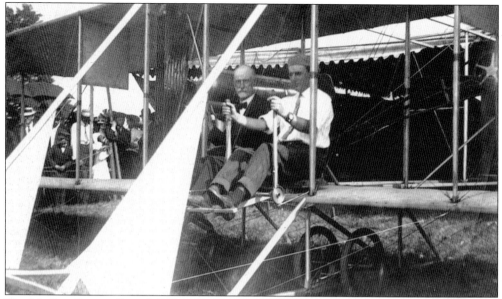

The Medina County Fair of 1915 offered Amos Ives Root the opportunity to be photographed in an airplane, but according to his grandson Alan, the little boy in the cap at the left of the photograph, the plane never did become airborne. "The pilot just bumped along and could barely get the plane to clear the fence," Alan later told his son. (Courtesy of A. I. Root Company.)

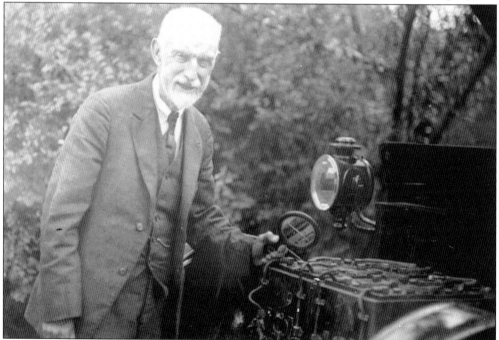

Root poses beside his electric Winton automobile. Every Sunday, he charged the car with electricity from the company generator and drove it to the Congregational church on the square. He was in the habit of leaving the key in the ignition, and the local boys would take the car joyriding while Root was at church services. After services were over, he was always disturbed—and puzzled—when the car did not start and he had to walk home. (Courtesy of A. I. Root Company.)

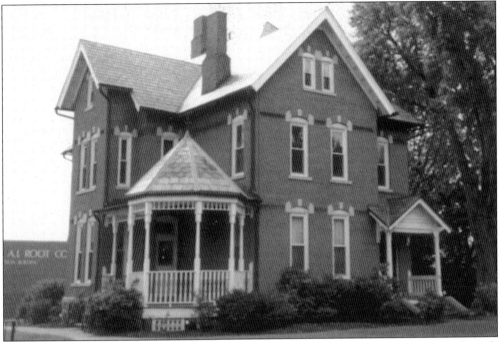

In 1883, Root and his wife Susan moved into this opulent house, a Queen Anne style with Eastlake detail. It is located beside the factory and cost $7,080 to construct. Presently on the National Register for Historic Places, it serves as a corporate office for the A. I. Root Company. (Courtesy of David Brown.)

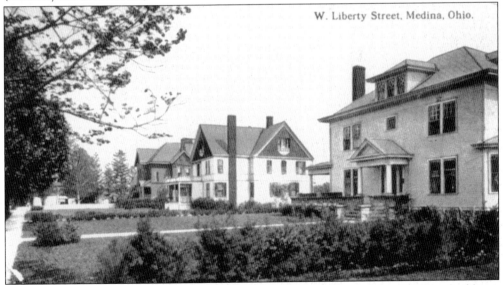

W. Liberty Street, Medina, Ohio.

This 1924 postcard shows Rootville on West Liberty Street just beyond the A. I. Root buildings. This area was designated as Rootville because many Root family members lived there. It was illuminated by lights powered by the dynamo at the plant. The Colonial Revival home beside Root's at the far left was built for his daughter Connie who was married to A. I. Boyden in 1899. Sons Huber (named for Sir Francis Huber, a blind scientist who studied bees) and Ernest and another daughter lived nearby. (Courtesy of MCHS.)

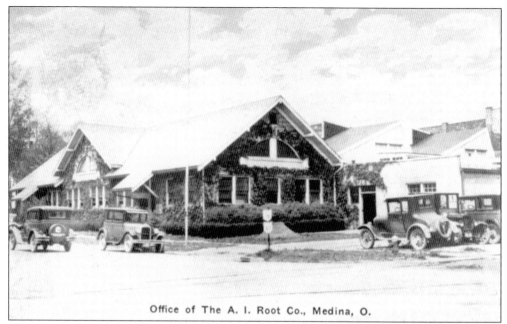

Office of The A. I. Root Co., Medina, O.

The office building across from the plant was built in 1906 to accommodate the growing number of employees. The company had previously expanded in 1883 and in 1890. This is where Amos Ives Root's original *Gleanings in Bee Culture*, regarded as the most authoritative bee magazine in the country, was—and continues to be—published every month. (Courtesy of A. I. Root Company.)

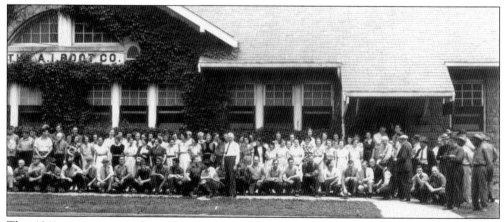

This 1941 group portrait shows that the A. I. Root Company was one of the largest employers in Medina. Frequently several generations of one family worked for Root's company. Early in the 20th century, the honey producing and packing business gave Medina the nickname of the Sweetest Town on Earth. (Courtesy of the MCHS.)

Seven

FAMILY SAGAS, PART II

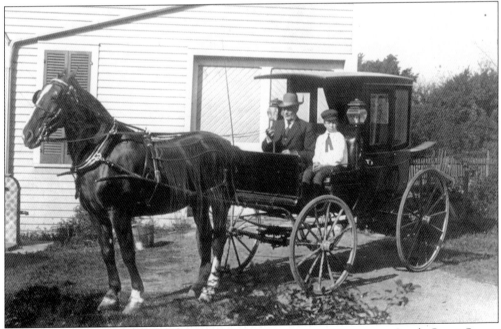

Windsor Whipple, partner in Whipple and Sipher, a successful store on South Court Street, prepares for a jaunt in his well-appointed carriage with grandson Windsor Kellogg. The year is 1909, and the back of the card, which was sent as a Christmas greeting, says "Our Auto." (Courtesy of David Kellogg.)

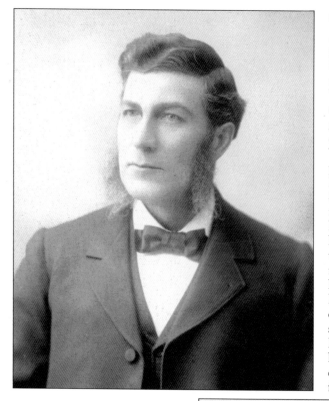

Windsor Whipple and his wife, Adelaide Hines Whipple, were prominent citizens in Medina in the early 19th century. He ran one of the leading stores, Whipple and Sipher, which sold groceries, crockery, and glassware. Windsor was born on April 28, 1859, in Montville Township. His father was a pioneer from New York State. He married Adelaide Hines of Summit County and was for many years a member of the Episcopal church and of the Royal Arcanum. Adelaide was a woman of strong convictions and ran the household with a firm hand. She was also a staunch Episcopalian. When her only daughter, also named Adelaide, strayed to another denomination, Mrs. Whipple put a codicil in her will stating her wish that the daughter return to the Episcopal fold. (Courtesy of David Kellogg.)

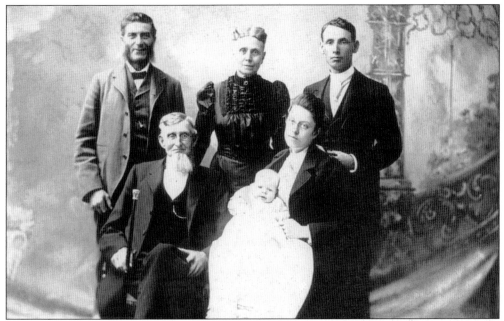

The occasion is the 1900 christening of Windsor Kellogg, grandson and namesake of Windsor Whipple. Seen from left to right are (first row) Adelaide Hines Whipple's father, James Hines, and Adelaide Kellogg holding baby Windsor; (second row) Windsor Whipple, Adelaide Hines Whipple, and their son-in-law, Charles Kellogg. Adelaide Kellogg and her husband met at Oberlin College. (Courtesy of David Kellogg.)

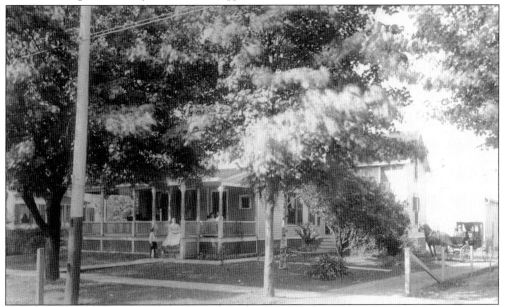

The Whipples lived in a spacious Victorian home on West Friendship Street with a carriage house and a wing for Adelaide Whipple's parents. Seen here are Adelaide Whipple, seated on the porch steps, with her grandson Windsor Kellogg standing beside her. At the back of the house, sitting in the carriage is Windsor Whipple, no doubt headed for another day at the store. The year is 1909. (Courtesy of David Kellogg.)

Windsor Kellogg was a noted common pleas judge in Medina from 1947 until 1975. He graduated from Ohio Weslyan University in 1924 and was a teacher and assistant principal at Medina High School for 17 years, until he was elected probate judge in 1940. He was appointed judge of Medina Common Pleas Court in 1947 to succeed a deceased judge, then was elected to that position and served for 28 years. He married college classmate Susan Guthry Kellogg who also taught at Medina High School. (Courtesy of David Kellogg.)

The store on South Court Street that supported the Whipple and Sipher families underwent several changes in the 20th century. It was a grocery store run by the Cannon family for two generations. In the 1980s, it was transformed into Gramercy Gallery, an upscale gift store. The shop is seen here in an illustration after the restoration of the square and the surrounding area. (Courtesy of Pam Miller.)

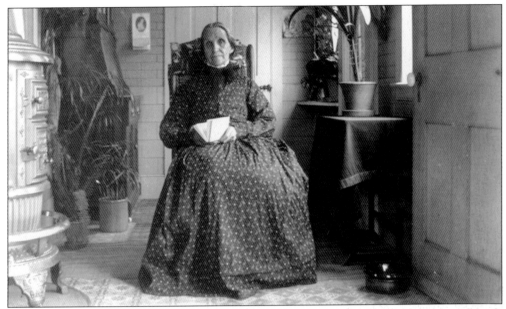

Sarah Almina Webber, wife of Alvah Washburn, was born in Monson, Massachusetts, on May 2, 1832. She was six years old when her family emigrated to the Western Reserve. The journey was made by wagon, canal boat, and steamboat. Sarah Almina Washburn recalled traveling in a steamboat that barely escaped going over Niagara Falls. According to a memoir written by her daughter Lucy, "Part of the passengers were praying and weeping, some were swearing and some were fiddling and dancing. By great efforts the boat was saved and the family reached Ohio in safety." (Courtesy of MCHS.)

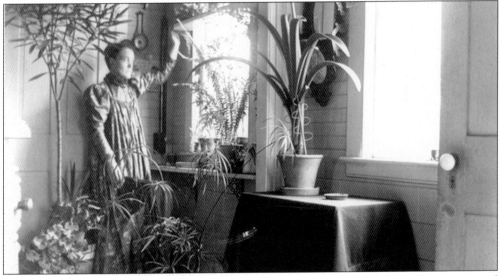

Lucy Adelia Washburn, oldest daughter of Alvah and Sarah was born in 1853. She was a noted plant expert—it was said of her "a dead plant would come to life if once it got into Lu's fingers," and she compiled an extensive private notebook of plant lore. Lucy worked for the Washburn family's close friend, Amos Ives Root. According to Root, "she did not take particularly to house work . . . she was not 'built' that way. . . . When we opened up a trade in seeds of honey plants, she had entire charge of that department, sending out catalogues and mailing seeds." Lucy never married and died in 1912. (Courtesy of MCHS.)

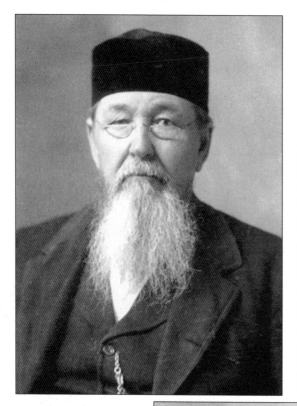

Alvah Washburn, seen here in two 1902 portraits taken hours apart, was born in Coventry, Connecticut, and came to Ohio to seek his fortune in 1852. He first settled in Hinckley, staying with a Methodist preacher named Elder Webber and helping to build houses and mills. On August 15, 1852, he married Elder Webber's daughter Sarah. After he built his own home, he started a tin shop in the barn, which evolved into a foundry. The family moved to Medina in 1860 where Washburn cofounded the Medina Foundry (which became the Henry Furnace Company in the 20th century), one of Medina's earliest industries, with a relative, Alfred C. Webber. (Courtesy of MCHS.)

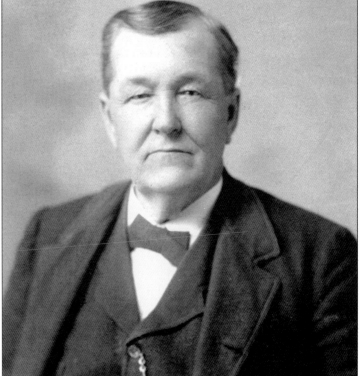

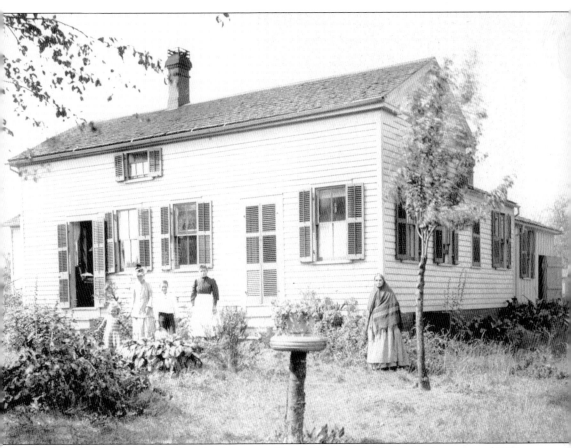

The Washburn family moved to this house on North Huntington Street in the spring of 1861, at the start of the Civil War. In this photograph taken sometime around 1890, Sarah Almina Washburn stands wrapped in a shawl at the far right. To the far left are her granddaughter Nell Hammerschmidt, her daughter Lucy Adelia Washburn, her grandson Will Hammerschmidt, and a housekeeper, Kate Pfanenschwarz. Daughter Lucy had happy memories of growing up in that house. In her memoir she wrote, "We had a little hill in the yard with a good well on top. We were on the corner of Smith Road and Elmwood Street so we could see everything. South of Smith Road was the creek with both wagon and foot bridges across, and that was where we spent much time fishing with bent pins." (Courtesy of MCHS.)

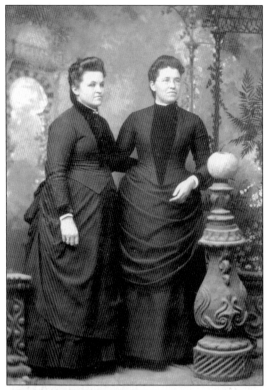

Alvah and Sarah Washburn also had two younger daughters, Lovina (left) and Sarah (right), seen in a portrait taken in the 1880s. Sarah graduated from the Lincoln School in 1876, a member of its first graduating class, and taught elementary school for many years before she married William Pritchard and retired. Lovina, a member of the class of 1878, married Louis Hammerschmidt, a shoemaker in the Griesinger Shoe Store on South Court Street. (Courtesy of MCHS.)

This family group was photographed in 1899. On the far right, Lovina Washburn Hammerschmidt sits in a rocking chair. Beside her stands her oldest son, Will, holding his little brother Bertie. Beside them stands her daughter Nell. Sarah Washburn Pritchard sits in the center beside her two stepdaughters. Her two sons died in infancy. (Courtesy of MCHS.)

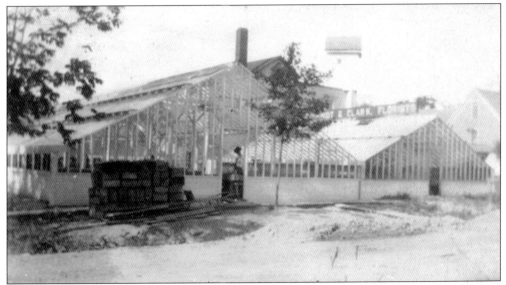

Lovina's son Will Hammerschmidt, bought a flower-growing business with his cousin Norman Clark, in 1902, while he was still in high school. It became enormously successful. The cousin left the business in 1924, and Hammerschmidt continued until 1955. It was the premier place in Medina to obtain flowers for every occasion. The greenhouse was torn down in the 1950s. (Courtesy of MCHS.)

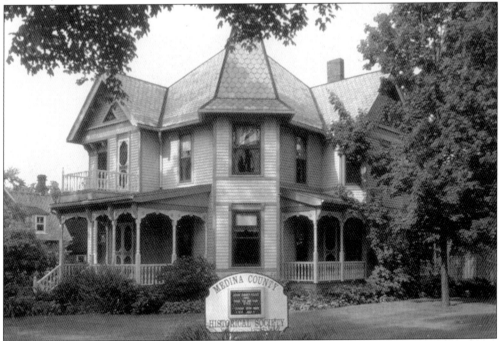

In 1926, Hammerschmidt and his family, wife Pearl and four children, moved into this elegant 1886 Eastlake Victorian home on North Elmwood Street. They were the third owners. The house had originally been built by John Smart of Staffordshire, England, and his family lived there until the dawn of the 20th century. The Smarts were followed by the Baldwin family, owners of the *Gazette*. The house has been the home of the MCHS since 1984. (Courtesy of MCHS.)

In 1941, when this photograph was taken, Will Hammerschmidt was an extremely successful businessman as a result of his greenhouse business. This allowed him to travel extensively and to collect United States and foreign postage stamps—something he began to do at the age of eight. His most cherished stamps came from Franklin D. Roosevelt's famed collection which Hammerschmidt purchased at auction. Eventually he possessed one of the largest collections in the state. He died in 1968. (Courtesy of MCHS.)

Pearl Hammerschmidt, seen here in 1941, taught two generations of students in the Medina schools before retiring at the age of 75. She did, however, take time off when her four children were very young. Pearl began teaching languages and eventually switched to mathematics. When needed, she helped her husband in the family greenhouse business, but her interests were more literary. She was fond of reviewing books at various clubs and meetings. Pearl died in 1972. (Courtesy of MCHS.)

Eight

FROM 1917 TO 1945

Armistice Day in Medina was celebrated with mixed emotions in 1918. Twenty-six young men from the village went to war, and seven did not return. Standing on the square in front of the courthouse are, from left to right, Mrs. Jake Borger, Louis Hammerschmidt, Mrs. D. Longacre, Mrs. Will Turner, Edna Loomis, and Hattie Daum. (Courtesy of MCHS.)

It was the custom for automobile dealers to display their cars at the Medina County Fair. Each dealer had his own tent, and the cars were lavishly decorated and driven around the track to show them to best advantage. In this 1916 photograph, Steve Handshue (left) and Lloyd Handshue (right) stand before an Overland car filled with five young women. They operated the Handshue Auto Company, the Overland dealership in Medina. (Courtesy of MCHS.)

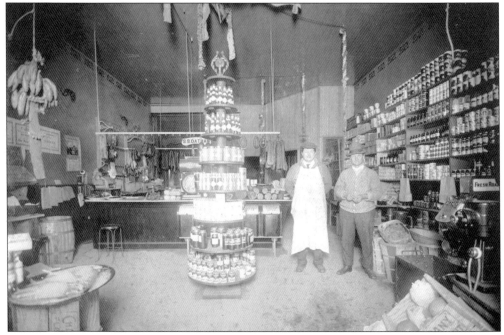

S. S. Oatman's Meat Market on South Court Street was started in 1871 and enjoyed a considerable trade. In advertisements, Oatman claimed that he bought directly from farmers and handled only the best grades of fresh and salted meat. The market shared the building with another Oatman Brothers shop, the stove and tinware business. (Courtesy of MCHS.)

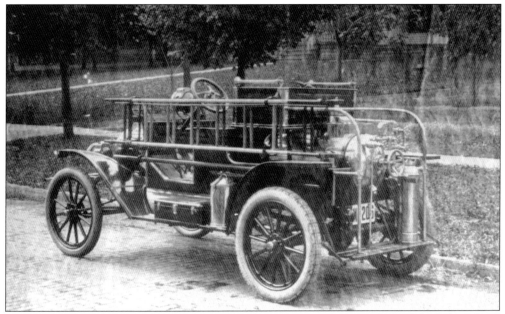

Medina's first motorized piece of firefighting equipment was a chemical truck built by a local company, Hallock Engineering, run by brothers Tom and Macy Hallock. Propelled by a Ford motor chassis, the Hallock, as it was called, was 1 of 22 such trucks built between 1913 and 1918. One of the Hallock trucks was placed on a train and shipped to Alaska. (Courtesy of MCHS.)

The Free Oil gas station opened on the corner of North Court and Friendship Streets in 1922. It was one of Medina's first gas stations. The man in the photograph is Louis Hammerschmidt, an employee of the Griesinger Shoe Store and one of their most skilled shoemakers. He was well-known for having made boots for Capt. Martin Van Buren Bates, the Giant of Seville, a former member of P. T. Barnum's international road show who settled in Medina County after retiring. (Courtesy of MCHS.)

By the early 1920s, enrollment in the public schools had increased again. After considerable debate, the decision was made to tear down the 1891 Medina Primary School to make way for a large, modern high school. The new structure opened in 1924 and became the hub of social life in Medina. The music and theatrical productions were always packed. Today it is the County Administration Building. (Courtesy of MCHS.)

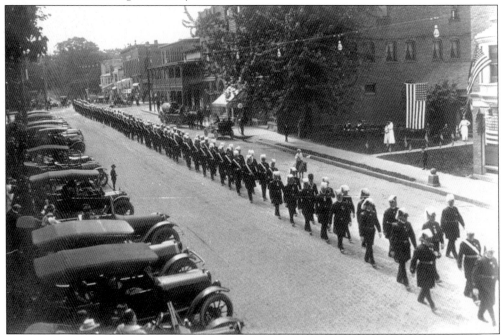

It is believed that this parade of Masonic Knights Templar, marching along the north side of Public Square, is celebrating the opening of the Medina Masonic temple in July 1925. The Medina Masonic Lodge was founded in 1819 and gathered membership from within a 25 mile radius. In 1824 and 1829, anti-Masonic movements forced the group to meet in Brunswick. For almost 50 years the Masons met in Old Masonic Hall, which was located in the building on the northwest corner of Court and West Washington Streets. (Courtesy of MCHS.)

This picture was taken behind the Garfield School building in 1933 or 1934. The teacher, at the far right, is Pearl Drake, instructor of the fifth and sixth grades. The children are, from left to right, (first row) Helen Navratil, Mary Beal, Vivian French, Joan Gunkleman, Virginia DeWitt, Nora Bradway, Helen Dyer, Rosalie Wilt, Dorothy Krieger, Helen Felton, Viola Gunkleman, Evelyn Hunt, Mary Jayne Bennett, and Evelyn Plants; (second row) Betty Gill, Patricia Anderson, Mary Ziegler, Hugh Riegger, Mason Shook, Eugene O'Brien, John Holcomb, Calvin Ganyard, Beatrice Baker, Charlotte Grimes, and Myrlin Hoertz. In the third row are Jack Ryan, John Horvath, Robert Gerspacher, Paul Fisher, Robert Freidt, Corwin Letterly, Junior Kendall, Robert Williams, Henry Felton, Paul Grimes, and Floyd Ganyard. (Courtesy of MCHS.)

The Medina High School band was an important part of the football experience in Medina. In this 1936 photograph, the band, standing in front of the Lincoln School, consists of seventh and eight graders as well as high school students. The band director, Charles Bart, was also the principal of Garfield School. The students are, front left to right, (first row) Robert Kindig, Ralph Morton, Frank Leach, and Elmer Zarney; (second row) Catherine Mellert, Lucille Herthneck, Daniel Pelton Jr., Richard Ziegler, Dorothy Gerspacher, Ronald Tollafield, Max Burnham, and Ebert Wiedner; (third row) Alice Hartman, Patricia Dean, Paul Reuman, Charles Ziegler, William Anderson, Gaylord Smith, James Ryan, Daniel Steingass, and Richard Longacre; (fourth row) Mary Snyder, Helen Mellert, Adeline Bradway, Santa Coselleto, Paul Huffman, Gordon Kisner, Richard Hammerschmidt, Leland Kulp, and Robert Reinhardt. (Courtesy Elmer and Betty Zarney.)

A new football stadium for Medina High School was begun in the early 1930s, but because of the Great Depression, the project languished. In 1938, Pres. Franklin D. Roosevelt authorized $31,326 for the WPA to construct the stadium. A year later the 1,000-seat, lighted facility—billed as a "dream come true"—was completed. With the band and the football teams wearing new uniforms, the stadium was dedicated in the fall of 1939. (Courtesy of MCHS.)

In this 1944 photograph, Medina High School's legendary couch, Sam Masi, intently watches his team play. As head coach from 1930 to 1945, he produced three championship teams: 1934, 1938, and 1940 in the old Northern Ohio League. On the left is John "Bub" Sailor, Medina High School class of 1943, a former football player, home on leave from the U.S. Navy. (Courtesy of Chuck and Nancy Masi.)

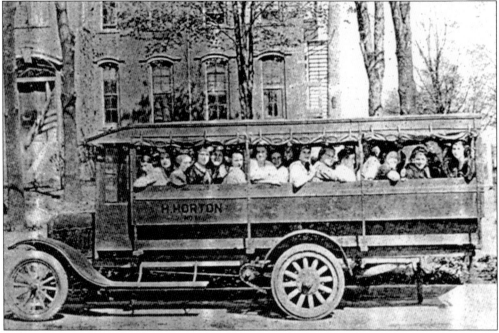

Harvey Horton drove the elementary school children who lived on the northern outskirts of the village to school in this wooden vehicle with canvas flaps. It belonged to him, and he frequently painted it, changing colors from bright yellow to bright green. It was known as the Kid Bus. In about 1930, the school system began transporting children in a traditional school bus. (Courtesy of Elmer and Betty Zarney.)

In this 1943 photograph, Ella Canavan's class seems to have varied reactions to the bottles of milk placed before them. The Penny Milk program, sponsored by the PTA, provided each child with a pint of milk at 10:00 a.m. and again in the afternoon to the kindergarten children. Each child paid 1¢ for the milk. (Courtesy of MCHS.)

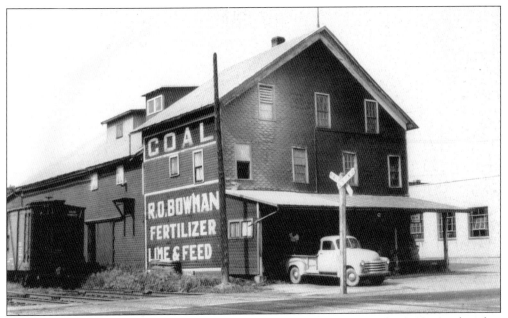

The R. O. Bowman Company in Medina provided feed and fertilizer to the farmers and coal to the households in town. Bowman also owned a Plymouth and DeSoto dealership. A gentleman farmer, he possessed a large farm with a pond and an orchard on Weymouth Road just outside the village. Today his barn has been converted into the Kindergarten Center for the Medina City Schools. (Courtesy of CDC.)

This advertising blotter harks back to a time when telephone numbers consisted of only four digits and homes were heated with coal. Older Medinians sometimes wax nostalgic about the cosiness of coal heat. They also recall, however, the black dust created when coal had to be shoveled into a furnace. (Courtesy of David Kellogg.)

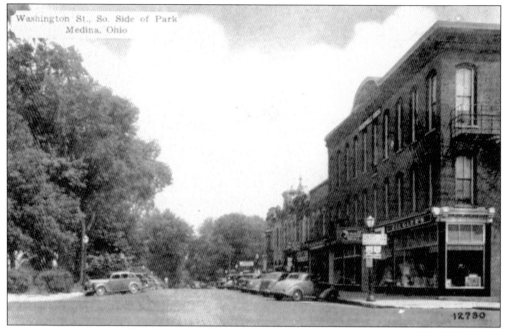

When *Pathfinder* magazine selected Medina as a "shining example of small town living," it was street scenes like this that it found attractive. The street is still paved in brick, the trees in Public Square Park, dating back to the Civil War era, are heavily canopied and the atmosphere is serene and still somewhat rural. (Courtesy of MCHS.)

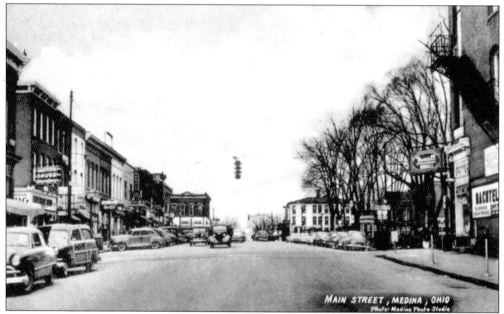

The Victorian buildings on the west side of the square look attractive and well-kept despite the presence of modern signage, and the business district bustles with activity in this scene from the 1940s. The square was the center of commercial activity for the village and it became especially lively on Saturdays, when the banks were open longer hours and families drove in from the country to shop. (Courtesy of MCHS.)

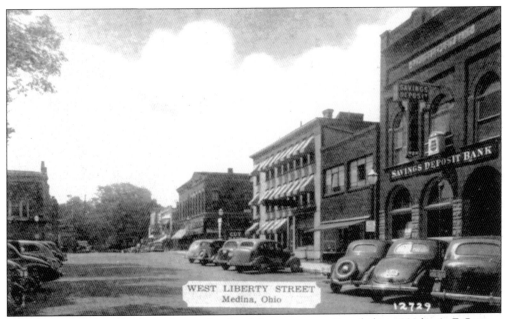

The Savings Deposit Bank on the north side of the square was founded in 1892 by A. F. Spitzer. It was the first bank to pay interest regularly on deposits, and the first to offer such innovations as safety deposit boxes, certificates of deposit, and installment loans. The bank, built of pressed brick and Berea sandstone, belonged to the Spitzer family for several generations. Today it is part of Key Bank. (Courtesy of CDC.)

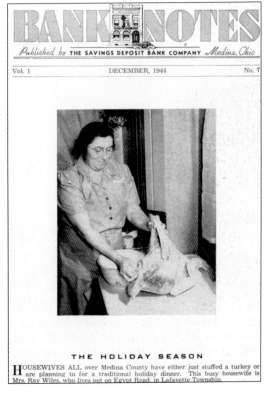

Bank Notes, a newsletter put out by the Savings Deposit Bank, ran from 1946 to the 1960s. Although it was an advertising vehicle for the bank, it included recipes, photographs, and warm, folksy stories about people in the town. It provided a chronicle of day-to-day life in Medina during the years that it appeared. (Courtesy of CDC.)

99

The War Bond Headquarters, a one-room clapboard structure located on the northwest corner of the square, generated a brisk business during the World War II years. War bonds were sold there—at one point Medina led the state—and war stamps. Everyone bought bonds and sometimes even gave them as wedding gifts. The little building became a symbol of the town and the country pulling together for the war effort. (Courtesy of CDC.)

The American Legion sponsored "Medina's Roll of Honor," a large white billboard created by painting over a brick wall on the corner of South Court and West Washington Streets. The name of every young man in the Armed Forces, as well as two female nurses from Medina and Montville Townships, was painted upon it. In this photograph, high school student Virginia Wheeler adds a name. (Courtesy of Elmer and Betty Zarney.)

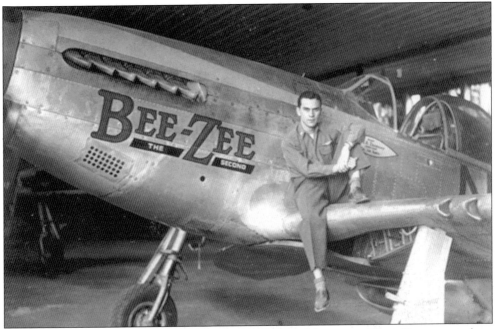

Among the many young Medinians who joined the armed forces was Elmer Zarney, seen here with his P51 fighter plane, *Bee-Zee the Second*, named for his wife Betty. Zarney flew 82 armed reconnaissance missions. His older brother Joe, also a pilot, ferried Gen. George S. Patton around Europe in a plane called the *Pride of Medina*. (Courtesy of Elmer and Betty Zarney.)

Tony's Candy Kitchen had been a popular spot on Public Square since the early 1930s. It offered a soda fountain, booths, a jukebox, and 15¢ sundaes. The owner, Tony Horvath, made the ice cream as well as the candy in the case in the front, which was delicious but a bit pricey. The place was particularly crowded after school let out, as well as when the movies at the nearby Princess Theater—and later the Medina Theater—ended. (Courtesy of CDC.)

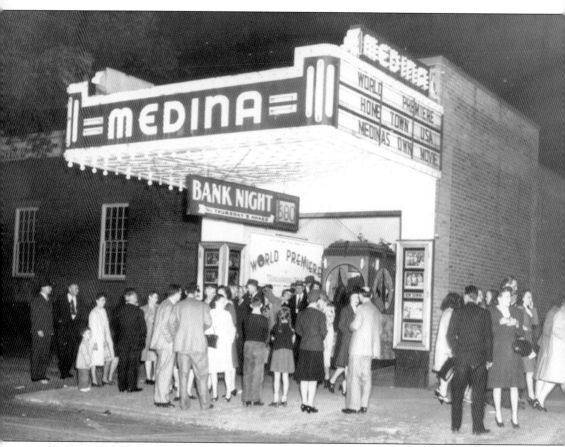

In 1944, *Pathfinder*, a weekly news magazine for small towns, selected Medina as a model of small-town life and, together with the film company RKO Pathe, produced a 15-minute movie about Medina called *Hometown USA*. In the film, a fictional lawyer, played by a middle-aged actor, dictates a letter sharing news about the folks back home with his nephew in the armed forces. All the people he talks about are actual residents of Medina. The actor ambles across the bustling square on his way to the high school, where he chats with Sam Masi, the football coach. Students crowd into Tony's Candy Kitchen. Ella Canavan watches her kindergartners play. It is a moment in time, captured forever. The world premier was held in April 1945 in Medina. The film is still available at the Medina Library. (Courtesy of CDC.)

Nine

ON THE
CUSP OF CHANGE

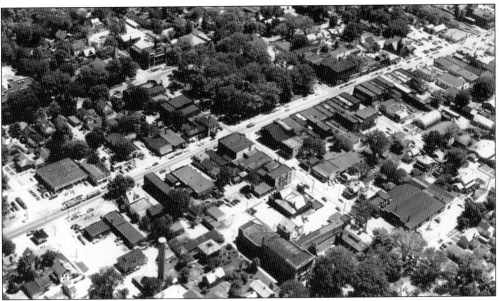

Medina native John Buchanan took a series of photographs of Medina from the cockpit of his plane in the 1950s and 1960s. This is a view of the village in the early 1950s. The courthouse is clearly visible and immediately behind it stands the 1851 jailhouse, a classic Federal-style structure of redbrick. It was torn down about 1954, as was the old American Hotel, which stood on the northwest corner of the square. The thick canopy of trees shading Public Square Park would succumb to Dutch Elm Disease by the end of the decade. Because the census of 1950 showed Medina to have a population of over 5,000, it was possible for the village to become a city. In the May elections of 1952, the citizens approved a measure that placed Medina under a city charter form of government starting in 1954. (Courtesy of CDC.)

Some Medina natives refer to this photograph as the beginning of the end. Shown is a section of Interstate 71, the 244-mile-long freeway that today runs the length of Ohio from Cleveland to Cincinnati. In the early 1960s, when this photograph was taken, I-71 came north from Columbus and ended in a wooded area just north of Route 18. In 1966, this northbound spur to Cleveland was completed. Suddenly the driving time to Cleveland was cut in half. Five years later, the June 9, 1971, edition of the *Cleveland Plain Dealer*, in a special supplement touting the attractions of Medina, announced that "I-71 Triggered Population, Industrial Growth." The story continues, "Medina County Commissioners believe I-71 has been responsible for increasing the county's population by 20,000. Industrial growth increased rapidly, as did real estate tax dollars." (Courtesy of CDC.)

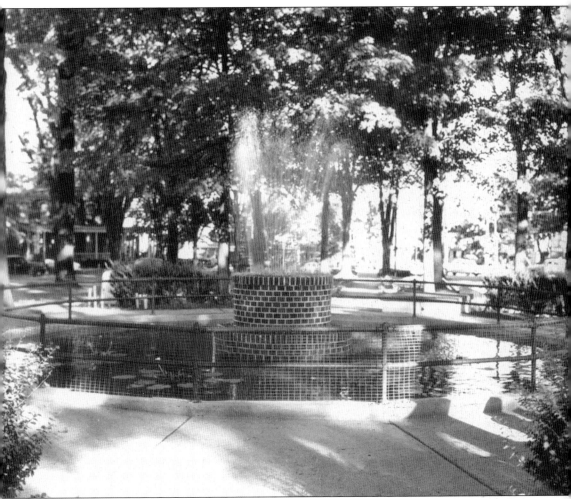

In July 1951, Freda Snyder, a Medina philanthropist, donated this fish pond and center fountain, which was located in the middle of Public Square Park. The fountain was electrically operated and equipped with colored lights to vary the color of the water. Snyder had seen it at a Cleveland garden show and purchased it for the park. Freda and her husband, Fred, owned Medina Farmers Exchange. She attended Medina Methodist Church and conducted a friendly rivalry with another member and philanthropist, Letha E. House, heiress to a Cleveland steel fortune. The two women had different styles. Whereas House only wrote checks, Snyder did not hesitate to scrub the church steps when necessary. (Courtesy of CDC.)

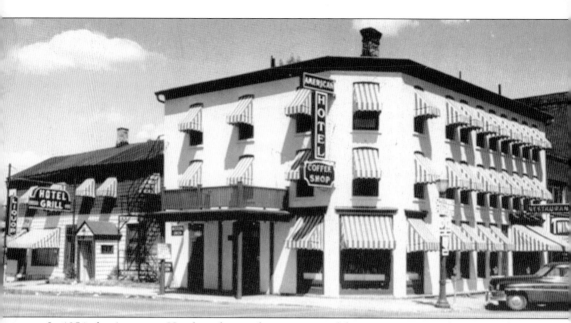

In 1954, the American Hotel on the northwest corner of the square was torn down to make way for a parking lot for the Savings Deposit Bank (now Key Bank) next door. A hotel had stood on that spot since the 1830s, when stage coaches from Cleveland regularly clattered up to the door discharging mail, parcels, and passengers. The village post office was once located in the room next to the lobby. Throughout the years, the hotel had been the scene of many village functions and social events. It had hosted people from every walk of life, from presidents to movie stars to traveling salesmen. The American Hotel survived the 1870 fire because the proprietor covered the roof with wet blankets and comforters. A Medina resident of the 1840s wrote that in those days it was "a nice clean rooming house which never did a rushing business except on political occasions." (Courtesy of MCHS.)

Spanky McFarland, star of the Our Gang movies, came to Medina in the 1920s and walked about the square holding his mother's hand, followed by a trail of excited children. In film footage that records that day, McFarland goes into the restaurant of the American Hotel for lunch and the crowd gathers outside, gawking at him through the window. Obligingly, McFarland takes his sandwich to the window and mugs for his audience. This photograph is a still of McFarland at the window of the restaurant. (Courtesy of CDC.)

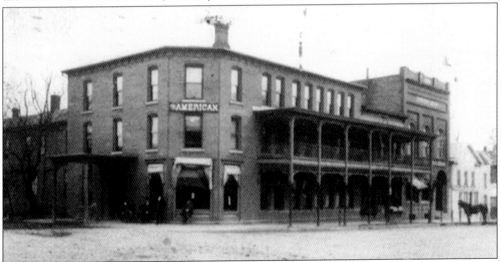

This postcard of the American Hotel in 1908 shows wooden plank sidewalks, horse-drawn carriages, and men idling in front of the bar. According to *Historical Highlights* written by the Medina High School class of 1966, "the stone-walled wine cellar beneath the bar room was supported by hand-hewn beams as thick as a man's waist." (Courtesy of MCHS.)

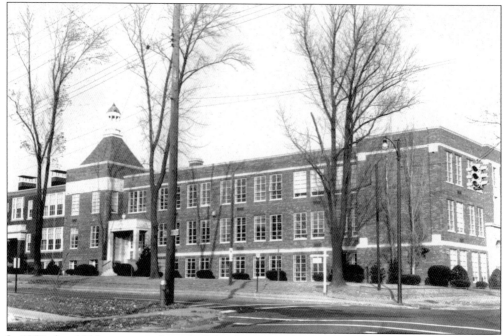

In 1950, the old Victorian-era Lincoln School was torn down to make way for a 24-room addition to the 1912 Garfield School located next door. The students packed books and supplies into paper bags and marched down the stairs of Lincoln School one last time. As the school was being demolished, the *Gazette* mourned the loss of the "link with the one-room school houses of the village." (Courtesy of CDC.)

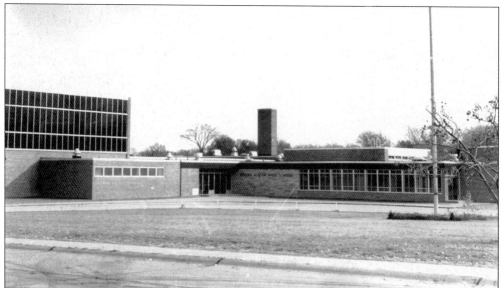

The surge of community growth continued during the 1950s, increasing the town's population by 60 percent. In 1956, a new high school large enough to accommodate 600 students was built at a cost of $1.2 million. It was located on Union Street, across the from the football field. The old high school building on North Broadway Street was then converted to a junior high—the first in Medina. (Courtesy of CDC.)

This scene is Medina in the 1950s on Route 18. It shows the rural character of the area in a time of transition. On one side of the street sit large new houses with newly planted shrubbery and concrete driveways. Across the street is a farm with an orchard and an unpaved road. Within a decade, this area of East Washington Street would become more densely populated. (Courtesy of CDC.)

Lake Medina, the city's reservoir, was funded by a $1 million bond issue in 1965. Between 1950 and 1965, Medina's population increased dramatically, and the traditional sources of water from streams and artesian wells was no longer sufficient. The situation became serious during dry summers, when emergency measures had to be taken to preserve the water supply. Today Lake Medina is used for recreational purposes. (Courtesy of CDC.)

RUSTIC HILLS COUNTRY CLUB DEVELOPMENT

RUSTIC HILLS is a truly unique residential country club development created for the discriminating homeowner. Here, distinctive SCHOLZ and custom-built homes are expertly blended into the natural setting of over 250 beautiful one-acre homesites. RUSTIC HILLS is ideally located and easy to reach. The main entrance is just two miles east of Medina on State Route 18.

The RUSTIC HILLS Country Club with its beautiful and spacious clubhouse will be the focal point of all recreational activities in RUSTIC HILLS.

Expertly maintained 9 holes of Pitch and Putt Golf for the entire family to enjoy.

Over five miles of Bridle Paths with excellent stable facilities for all who love horses and riding.

Sparkling water and fighting fish mean relaxation and companionship on one of RUSTIC HILLS' beautiful lakes.

"LIVE BETTER ELECTRICALLY"..... THIS MEDALLION IS YOUR ASSURANCE THAT YOUR NEW HOME IS ELECTRICALLY PLANNED TO MEET BOTH PRESENT AND FUTURE LIVING NEEDS

A Medina County farm with rolling topography was transformed into an award-winning country club community in 1958. Developers Richard Huxtable and Edward Mears decided that the 340-acre property one mile west of the I-71 exit would be desirable for people from Akron and Cleveland who wanted a combination of suburban and country living. They created winding streets and cul-de-sacs and damned up several springs and a branch of the Rocky River to create private lakes. The developers also partnered with a national builder of luxury homes and touted the proximity to Medina with its "New England flavor of a bygone era." At the time of its creation, the concept of the country club community was unusual in the United States, and builders and developers from across the country flocked to view this innovation. Several magazines including, *Home and Garden* and *Better Building*, wrote about Rustic Hills, and for three years in a row, the Look Magazine National Award was presented to Richard Huxtable and Edward Mears. (Courtesy of Friends of the Cemetery.)

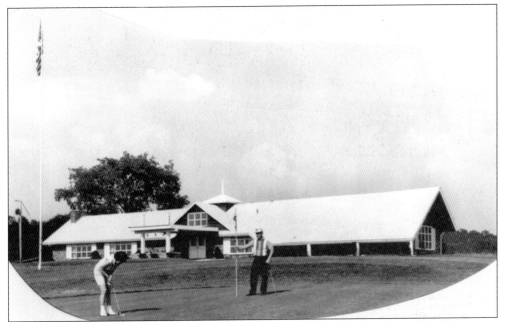

Rustic Hills Country Club, with a nine-hole golf course, a well-stocked lake for fishing, and five miles of bridle paths, added to the mystique of the community. Rustic Hills attracted many executives and upper income families, many of them newcomers to the area. Developer Edward Mears and his wife Pat play golf in front of the club house sometime in the early 1960s. (Courtesy of Friends of the Cemetery.)

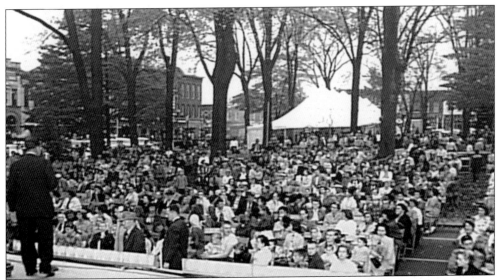

In 1957, H. G. Blake's Old Phoenix National Bank turned 100 and the board of directors celebrated by hosting an ox roast for the community. Actually there wasn't an ox to be seen, only enormous sides of beef, roasted over coals and sliced into several thousand sandwiches. A large white tent was pitched in Public Square Park for dining, and a stage, for entertainment and speeches, was erected on the east side of the square. Standing at the microphone is Paul Jones, president of the Old Phoenix National Bank. (Courtesy of First Merit Bank.)

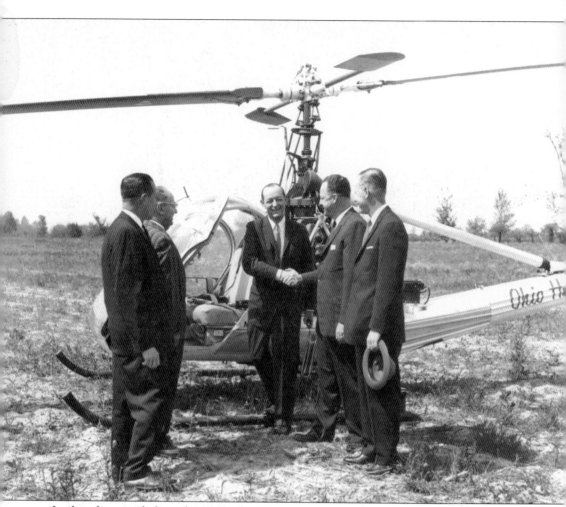

In this photograph from the 1960s, developer Amos Mears (second from the left) and Elbridge Moxley, president of Medina Supply Company (second from the right), welcome a visitor to Medina's new industrial park. In the 1950s, Mears, a Cleveland entrepreneur and financier who moved to Medina after retirement, hit upon the idea of expanding Medina's industrial base. He convinced Medina City Council to annex 600 acres of cow pasture west of the city and to extend utilities. Then he traveled across the country, persuading companies to relocate in Medina. Today the businesses in the industrial park still provide a major source of employment in Medina. The first man on the left is Paul Jones, president of the Old Phoenix National Bank, now First Merit Bank. (Courtesy of Friends of the Cemetery.)

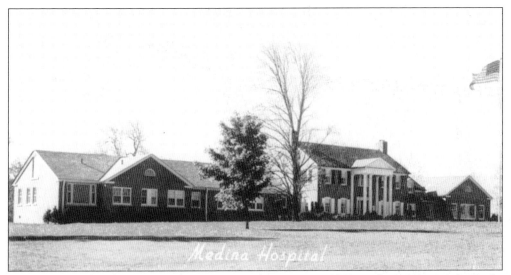

The Medina Chamber of Commerce convened a group in 1942 to discuss raising funds for the establishment of a private hospital in Medina. As a result of this meeting, the Medina Hospital Association was created, and a campaign to raise $100,000 was launched. The money was quickly raised, and the T. J. Weidner home on Route 18, the Akron-Medina Road, was selected as a suitable venue for remodeling and enlarging. The hospital was dedicated in October 1944. In this 1947 postcard, Medina Community Hospital, with its white columned entrance, still resembles a gracious country home more than a medical facility. (Courtesy of Elmer and Betty Zarney.)

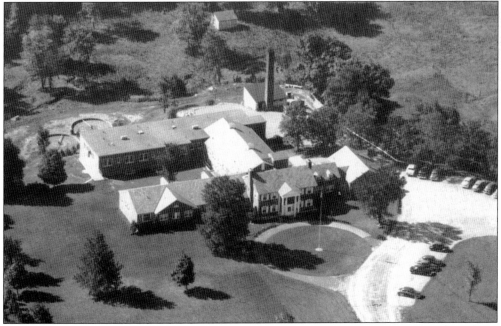

This aerial photograph shows Medina Community Hospital in the 1960s. Two wings have been added, one in 1954 and one in 1960. One of the hospital's main supporters was Freda Snyder of the Medina Farmer's Exchange. She donated a flock of sheep to keep the spacious lawns clipped. (Courtesy of CDC.)

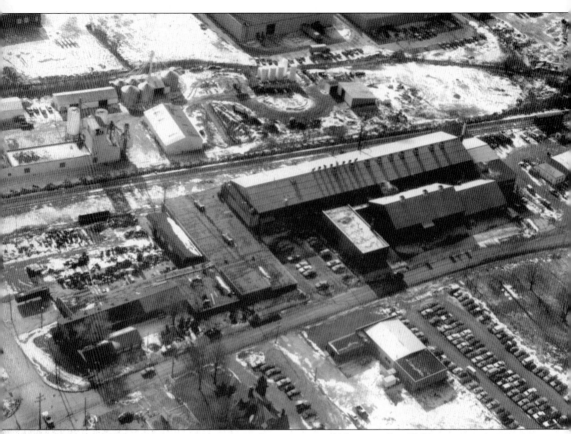

The Permold Company, seen here in a dramatic aerial shot in the 1960s, was once a major business, and one that had an impact on growth in Medina. The company, founded in Cleveland in 1921 by former employees of the Aluminum Castings Company, moved to Medina in 1941. The Medina Chamber of Commerce raised funds for the purchase of land and moving expenses to induce it to come. The Permold Company began its Medina operations in July 1941 in a 65,000 square foot plant on the corner of West Liberty Street and South State Road. The World War II era was the high point in the Permold Company's history. Its entire output went into the war effort, with castings for vehicles and aircraft. To obtain sufficient wartime manpower, the company hired men from the South and displaced persons from Europe to work in the plant. The employment reached a peak of 800 during the war years, and government housing was provided since there was no low cost housing available in Medina. The company has been out of business since 2000. (Courtesy of CDC.)

Ella Canavan School—Medina's first new elementary school since the construction the Garfield School in 1912—was dedicated on October 9, 1960, and named in honor of "Miss Ella," the revered kindergarten teacher of two generations of Medina students. The school was located on Lawrence Street, in the fast-growing southwest area of Medina, which was rapidly filling up with new ranch-style homes and young families. The *Gazette* called her "The most beloved teacher ever to grace a classroom." Hundreds of her former students came to the dedication ceremony. One of the principal speakers was Vernon Stouffer, founder of the restaurant and food chain and a former student. In his speech, he mentioned that Canavan had taught approximately 3,500 kindergarten students, and he read a congratulatory note sent to her by Pres. Dwight Eisenhower. Later that day, he took her for a ride on his yacht on Lake Erie. Medina's first elementary school library was dedicated in memory of Canavan in 1966, with proceeds from a memorial fund created in 1964. (Courtesy of CDC.)

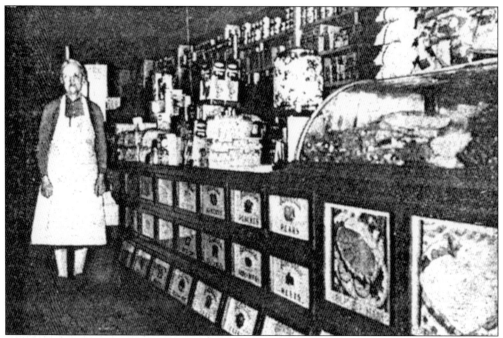

Ida Cannon sold groceries in the former Whipple and Sipher store for several decades. She stood behind the counter, and customers had to ask for whatever they needed. Everything was wrapped in old-fashioned brown paper and tied up with string. Cannon's store delivered groceries in a 1930, wood-paneled station wagon. The teenage delivery boys that she hired referred to the vehicle as the Cannonball. (Courtesy of Elmer and Betty Zarney.)

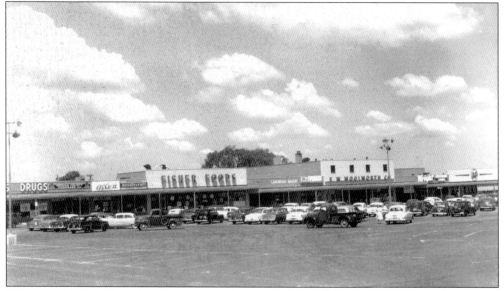

When the Medina Shopping Center opened one mile from Public Square, it sounded the death knell for the stores and merchants uptown, as the square shopping area was then called. Acme and A&P had both been near the square, but since they had no room to grow, they quickly moved to the new shopping center. The customers followed, attracted to the new, self-service shopping, and the acres of free parking. (Courtesy of CDC.)

Ten

RESTORATION

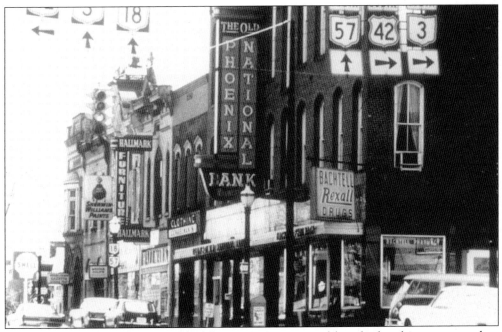

In the late 1960s, Public Square had become an eyesore, although the change occurred so gradually that few people appeared to notice. The Victorian buildings were covered with garish neon signs and the streetscape was cluttered with overhead wires and masses of traffic signs. There had been a move to tear down the 1841 courthouse—which left some long time residents shaken—and there was talk of paving over part to the square to provide more parking. Merchants on the square complained that the Medina Shopping Center was drawing away customers. The beautiful square that had risen like a phoenix from the ashes of the 1870 fire was suddenly in danger again. (Courtesy of CDC.)

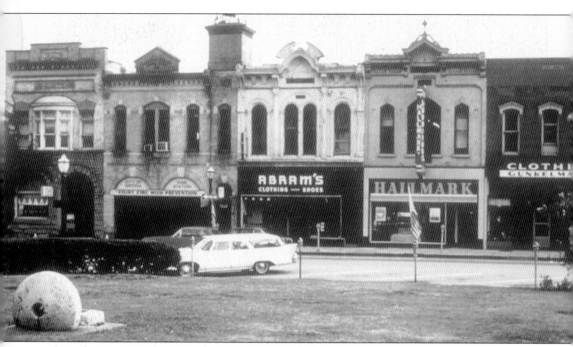

It took a stranger from another town to sound the alarm. F. Eugene Smith of Akron gave a slide-show presentation entitled "Why Ugly, Why Not?" to the American Association of University Women in Medina in January 1967. He suggested to the audience that they "look, but don't see." He pointed out how rundown and shabby the old buildings on Medina's square had become and made suggestions for improvement. Take down the neon signs, he told them. Paint the buildings. Get rid of the mass of electric wires. Return the town to its original beauty. Some audience members were offended. Others were inspired to restore the square. A small group met after the slide presentation and decided to do something. (Courtesy of CDC.)

The CDC was created shortly after Smith's talk. It was a mixture of old and new Medina. The group included a lawyer, several businessmen, a writer, a community activist, an antique dealer, and two artists. The group decided to remain independent and not accept state or federal money. Seen here are three members of the CDC, from left to right, P. M. Jones, who made countless speeches to civic groups to convince the townspeople of "what they can have;" Elaine Lamb, a community activist; and artist Elmer Zarney. (Courtesy of CDC.)

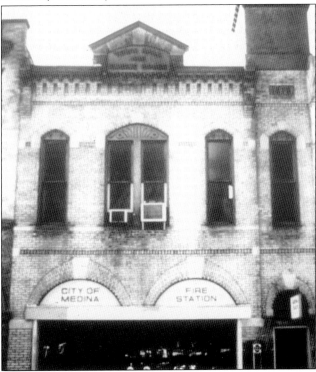

Eight months after getting organized, the CDC tackled their first project, the 1878 Town Hall and Engine House. Structurally there was nothing wrong with the building, but it was desperately in need of cosmetic repair. Using the philosophy of "a picture is worth a thousand words," artists Ken Lipstreu and Elmer Zarney researched Victorian architecture and color schemes and produced a rendering. (Courtesy of CDC.)

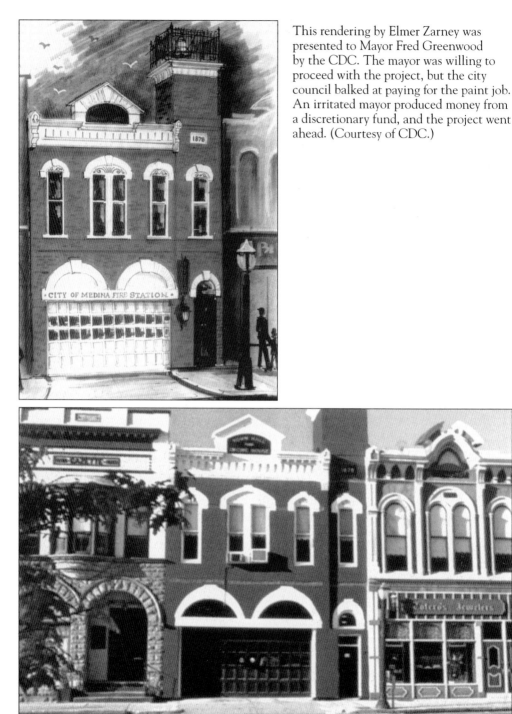

This rendering by Elmer Zarney was presented to Mayor Fred Greenwood by the CDC. The mayor was willing to proceed with the project, but the city council balked at paying for the paint job. An irritated mayor produced money from a discretionary fund, and the project went ahead. (Courtesy of CDC.)

A headline in the *Medina County Gazette* read, "Police Station is First Mountain to Climb." The result was impressive. Suddenly the goals of restoring the square to its former splendor and of saving it economically seemed possible. The CDC renewed their efforts, approaching every business owner on the square. But not all of them were convinced. "Some people told us we were nuts," said one CDC member. (Courtesy of CDC.)

The project that gave the CDC its major boost was the restoration of the Old Phoenix National Bank (now First Merit Bank). H. G. Blake's building—once the center of social and cultural life in the village—was 95 years old and as shabby as the rest of the square. The board of directors had already decided to purchase land away from the square and construct a modern new facility. They felt that new construction would be more cost effective and less disruptive to business than remodeling. Nevertheless CDC made their pitch. (Courtesy of CDC.)

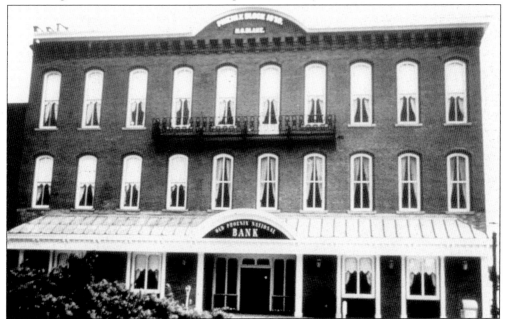

After much thought, the board of directors agreed to stay on the square. They invested $250,000 in the project, which closed the main branch for one year. The result was a handsome restoration that won an award from the Akron chapter of the American Institute of Architects (AIA). This paved the way for the rest of the merchants on the square to follow suit. (Courtesy of CDC.)

Colorful renderings, like this one by artist Ken Lipstreu, were the cornerstone of CDC's efforts to convince the building owners to restore their buildings. The CDC made the argument that a more attractive streetscape would boost economic vitality, and that old buildings could be modified to suit the needs of modern business. (Courtesy of CDC.)

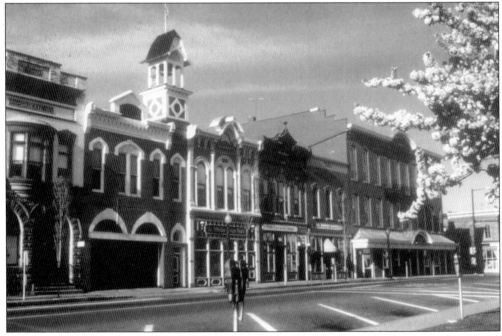

This is the south side of the square after the restoration. Ohio Edison agreed to move the electric lines underground and was persuaded to restore the 1925 white way street lamps on the square. The result was the salvation of what the CDC called "one of the most authentic Victorian towns in this part of the United States." (Courtesy of CDC.)

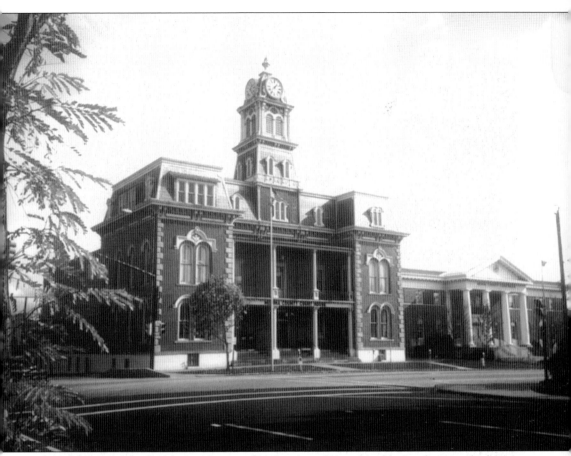

In the mid-1960s there had been serious talk of tearing down the old courthouse, which was prevented only by a series of indignant letters to the editor of the *Gazette*. In 1973, with funds provided by the National Trust for Historic Preservation and matched by the Medina County Commissioners, a scholarly restoration of the courthouse was initiated. The original brick was restored by removing a coat of bright red paint, the capitals on the columns along the front were replaced (the original ones had been removed and taken to a landfill), and the clock tower and mansard roof were preserved. Once the courthouse was returned to historic authenticity, it was placed on the National Register of Historic Places. Beside the old courthouse stands the new, Federal-style courthouse which opened in 1969. It replaced two previous structures, the Strong house, an old Western Reserve–style home, and the Eagles Club. (Courtesy of CDC.)

By 1974, most of the square was restored. The following year, the National Trust for Historic Preservation presented Medina with an award for "Significant Achievement in Historic Preservation in the United States." The square was also placed on the National Register of Historic Places. Standing before the courthouse are the following CDC members (from left to right): Ken Lipstreu, Elmer Zarney, Rick Grice, Barbara Galloway, Cynthia Szunyog, Elaine Lamb, Barbara Aufmuth, and Charles Griesinger. (Courtesy of CDC.)

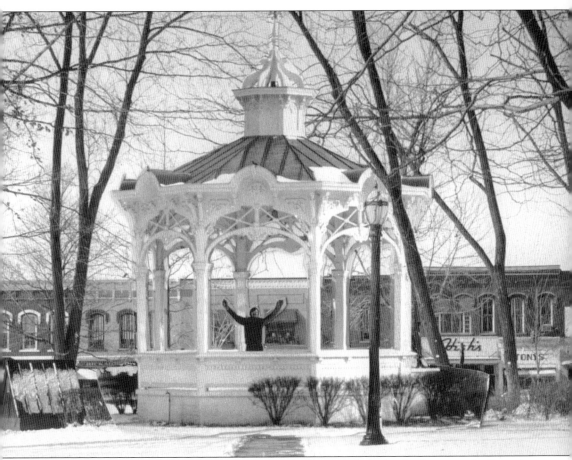

After Public Square was restored, the CDC felt that the park lacked a finishing touch. Several members thought that a Victorian-era bandstand or gazebo might be appropriate. An 1879 gazebo in the town of Belleville came under discussion. CDC artist Kim Zarney drove to Belleville accompanied by Ross Trump, an antique dealer, who pronounced the Belleville structure to be historically correct for Medina's square. Zarney photographed the gazebo and, in keeping with CDC's philosophy of "a picture is worth a thousand words," superimposed that photograph on a likeness of Medina's park. Everyone liked it. (Zarney is the man in the gazebo.) The Letha E. House Foundation funded the cost of construction. Ironically, House had the last word in her rivalry with Freda Snyder. Snyder's 1952 fishpond with the lighted fountain was removed, and on June 6, 1976, the gazebo was officially dedicated with a band concert. (Courtesy of CDC.)

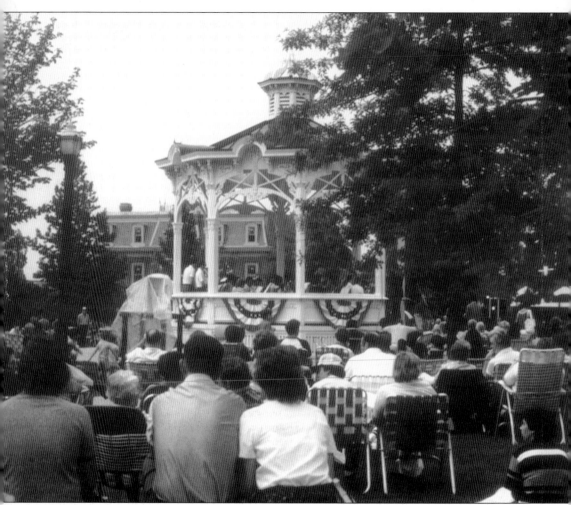

The Friday evening band concerts held on Medina's square in June and July are a tradition that has endured for well over a century. Old photographs show musicians in horse-drawn wagons—usually about 12 to 15 of them blowing horns and being carted around the square by a team of horses. These days the Medina Community Band performs in the gazebo. Between 60 and 80 volunteers, including students, teachers, and former professional musicians make beautiful music on summer nights for an audience seated on folding chairs and blankets. The park also hosts six ice-cream socials during the concerts, sponsored by various church and civic groups. In a community attitude survey conducted several years ago by the Junior Chamber of Commerce, one of the questions asked was "What do you like most about Medina?" The large majority of those responding to the survey replied, "The summer band concerts."

INDEX

ACROSS AMERICA, PEOPLE ARE DISCOVERING SOMETHING WONDERFUL. *THEIR HERITAGE.*

Arcadia Publishing is the leading local history publisher in the United States. With more than 3,000 titles in print and hundreds of new titles released every year, Arcadia has extensive specialized experience chronicling the history of communities and celebrating America's hidden stories, bringing to life the people, places, and events from the past. To discover the history of other communities across the nation, please visit:

www.arcadiapublishing.com

Customized search tools allow you to find regional history books about the town where you grew up, the cities where your friends and family live, the town where your parents met, or even that retirement spot you've been dreaming about.